DESIGNER'S
GUIDE TO

SCANDINAVIAN
P A T T E R N S

DESIGNER'S GUIDE TO

SCANDINAVIAN
P A T T E R N S

THOMAS
PARSONS

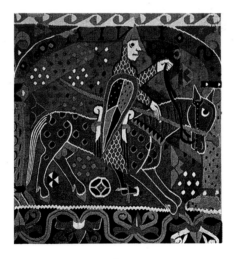

CHRONICLE BOOKS
SAN FRANCISCO

First published in the United States in 1993 by Chronicle Books, San Francisco

First published in Great Britain in 1993
by Studio Editions Ltd
Princess House, 50 Eastcastle Street
London W1N 7AP

Printed and bound in Hong Kong

Library of Congress Cataloging in Publication Data

Parsons, Thomas
 Designer's guide to Scandinavian patterns / Thomas Parsons.
 p. cm.
 Includes bibliographical references.
 ISBN 0-8118-0495-X
 1. Design—Scandinavia—Patterns. I. Title. II. Title: Scandinavian patterns.
NK1457.A1P37 1993
745.4′4948–dc20 93–3315
 CIP

Distributed in Canada
by Raincoast Books
112 East 3rd Avenue
Vancouver, B.C.
V5T 1C8

10 9 8 7 6 5 4 3 2 1

Chronicle Books
275 Fifth Street
San Francisco, CA 94103

INTRODUCTION

The patterns illustrated in this book, with their origins in paganism, speak of indigenous traditions and mythologies that lie resolutely outside of mainstream European developments, centered as these are on Classical Rome and Renaissance Italy. It is these shared traditions and roots that provide the fundamental link between the five Scandinavian countries: Norway, Sweden, Finland, Denmark, and Iceland.

Not until the Peace of Copenhagen, signed in 1660, were the Scandinavian countries' present-day boundaries finally settled. Before that time political relations among all five nations were unstable and closely, even confusingly interlinked. Norway had been governed by both Denmark and Sweden; Iceland by Norway and Denmark; Sweden by Denmark; and Finland by Sweden. Politically it is a tangled history, but culturally the peculiarly conservative yet inventive folk tradition that unites Scandinavia also sets it clearly apart from the rest of Europe.

Each of the Scandinavian countries came relatively late to Christianity; each was transformed by industrialism, but also relatively late. For both these reasons, national and local traditions of craftsmanship and design continued to flourish there, from ancient times, in an almost uninterrupted line. They were enhanced rather than redirected by the motifs brought home by the far-ranging Vikings. In the seventeenth and eighteenth centuries well-financed attempts in fact were made in both Denmark and Sweden to establish viable silk and linen manufacturing industries that were for export **[70, 76]**.

To this end, foreign weavers were encouraged to form part of the indigenous workforce, and they brought with them elements of foreign design. The textiles that were produced, aimed as they were at international markets, followed patterns that were imported from France, England, and Germany. The businesses foundered, however. At the same time, traditional, smaller crafts continued to be practiced much as they had been for hundreds of

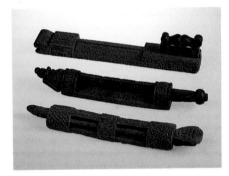

1 *These intricately carved, wooden mangle boards date from the seventeenth century and bear a pleasing mix of patterns, including a stylized dog, typical of the period. The boards were used for pressing handkerchiefs and other linen articles. They were carved with great skill, as they were often given as pledges by men to their prospective wives.*

years. It helped to maintain Scandinavia's traditional designs that native production was heavily protected by high tariffs from foreign imports. Also, into the nineteenth century rich farmers in southern Sweden, for example, commissioned costume ornament from local craftsmen that followed medieval patterns; they spurned the more

modern and fashionable but imported patterns that by then were available **[1]**.

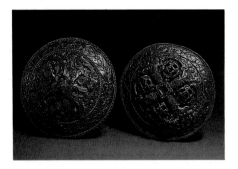

2 *These gold brooches were uncovered as part of the Hornelund hoard in Denmark. The splendid filigree and granulation work indicate that these brooches were made for a chief or king. Viking men wore as much jewelry as the women – if not more.*

Scandinavian patterns do display a peculiarly rigid conservatism. Folk traditions of ornament are, in any case, particularly resistant to change. For example, the motif of the horse in Norwegian ornament, first recorded on pre-Christian runestones, reappears in other media right up until the nineteenth century **[4, 33, 75, 78–84, 107, 108]**. (The mysterious Runic script itself survived until the eleventh century, long after most other European countries had adopted the Roman alphabet.) Yet despite their conservatism, these patterns also testify to an extraordinary variety in their inventive and imaginative adaptation of stock forms and motifs.

One further reason for the unparalleled survival of so many ancient patterns from the Scandinavian countries needs to be mentioned – the geographic isolation. Iceland was the most inaccessible and hence the most immune from stylistic developments going on in the rest of Europe. Colonized by Vikings at the end of the ninth century and converted to Christianity in 999 A.D., Iceland functioned as an independent republic until it ceded to Norwegian rule in 1292, and then to the Danish in 1380. It regained its independence only in 1944. Throughout much of the Icelanders' history, they lived in rural communities. Crafts such as weaving and wood carving existed independently of any urban or bourgeois patronage until the nineteenth century. The church naturally provided a focus for many of these local skills, though no medieval churches survive today and much wood carving was destroyed in the Reformation **[45]**.

Iceland's bleak, hilly terrain supported large numbers of sheep, making both woven and embroidered textiles the mainstay of the folk craft tradition. If little survives today that dates from before the nineteenth century, still it is clear that the patterns used on these colorful textiles were based on ancient and traditional models.

Iceland boasts little forested land. Wood is scarce. Houses were and are still built out of turf; heating is provided by peat. The wood that was used for domestic uses tended therefore to be richly carved – an indication of its rarity and value. Moreover, to balance the expense of importing much of its wood, Iceland has long needed exports. One of its principal sources of income was formerly manuscripts. From the tenth century onward, following the introduction of writing with the first Christian missionaries, manuscript copying and illumination developed into one of Iceland's largest industries. The importance of the written word is reflected

in the patterns found on old wood carvings. Iceland, in fact, became the only Christian country to use lettering as ornament [67, 68].

The earliest records of the other Scandinavian countries show them also to have begun as tribal, agricultural communities. Patterns or emblems that survive from these times display motifs such as the swastika and the solar disc that are common to many ancient cultures [7, 8, 9, 62, 86, 95]. Then the eighth to the eleventh centuries saw the rise of the Vikings. During this period the Scandinavian countries developed from a loosely connected, predatory tribal structure into aggressive, organized nation states that professed, at least, allegiance to Christianity. The Viking period saw the change from communities that survived on subsistence farming into larger, national unities wholly oriented toward trade. Viking ornament was intended, by its richness and ostentation, to be seen as a direct reflection of the people's trading prowess [2]. The lack of any large sources of gold or silver in the Scandinavian countries did stimulate the Vikings to steal or trade for it [12–15, 26–28, 33]. From a relatively early period, as a result, alien styles of ornamentation crept into native patterns and designs [29, 31, 36, 41–44, 50].

Denmark, like Iceland, lacks large areas of forest of its own, and so most of its craft traditions have been built up in arts other than carving [10]. The opposite is true of the densely forested areas of northern Norway, Sweden, and Finland, where the tree appears as an integral part of many traditional patterns [4, 39, 47, 48, 78–87, 104, 107, 115–16]. Some of the richest designs and patterns originated in the southern Scandinavian lands, whose flat terrain and fertile soil brought wealth and power to the people who lived there. Nevertheless, the relative inaccessibility of large parts of each of these countries except Denmark has been a prime factor in the resistance to foreign influences that is characteristic of their patterns.

Foreign influences can in fact be discerned in the patterns that continued to be used in these traditional crafts; these influences, however, were absorbed early on into the native tradition. While it is possible to see traces of Byzantine or Asian workmanship in Viking or medieval Scandinavian patterns, these elements are invariably subordinated, never dominant [24, 69, 57], until in the sixteenth and seventeenth centuries fabrics were produced in the designs that were specifically for export.

The early foreign influences on Scandinavian patterns are the direct result of the Vikings' extensive seaborne trading. In their fast, shallow longships they traded to both the east and the west. They traveled to England, Ireland, Greenland, France, and North America but also sailed down the

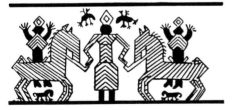

3 *This pattern shows one of the most ancient and enduring features of Scandinavian, especially Finnish, patterns – the giant and horses. The design probably has its roots in myth. It is tempting, for example, to attribute the giant who restrains the horses to Odin, the supreme, creator god of Scandinavian mythology.*

rivers of Russia to make contact with the Eastern Empire based on the Black Sea. Viking merchants established trade routes, for example, with Byzantium, where Nordic mercenaries are documented as having served in the Imperial Guard, and also founded colonies in Russia, as at Kiev, along the way. At Byzantium they could also do business with Chinese and Syrian merchants. Viking remains have been excavated in modern-day Russia, while Byzantine, Chinese, and Syrian remains have been found in Scandinavia. Indeed, Arabic, Germanic, and English silver coins, dug up at Viking burial sites in the thousands, testify to the volume of this trading activity.

These eastern connections proved highly influential in the development of Scandinavian patterns: the influence persisted long after the eleventh century when the trading links came to an abrupt halt. For example, eastern-style onion domes were still being built on Finnish churches up to the seventeenth century. It was the Mongol invasion of Russia that severed these economic connections between Scandinavia and the East. (In the fifteenth century, when it is possible to find examples of an Italian influence in textile patterns **[51]**, the textiles invariably had been made for the aristocracy, and their patterns did not filter down into the work of craftsmen.) It was in the homespun textiles and the lace embroidery that the eastern influence took root. It has survived to the present century **[14, 120]**.

Most of the patterns illustrated in this book have sources in the social rituals of Scandinavian rural life: in other words, in the traditional crafts of embroidery, weaving, lace making, and wood carving. Thus

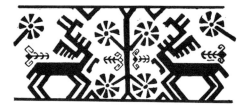

4 *The giant and horse motif has undergone many changes, the most significant of which was the metamorphosis of the giant into an enormous tree, possibly the Yggdrasil or tree of life. The horses here might also be seen as reindeer.*

the distinctive, brightly colored woven textiles made in the southern Swedish province of Skåne, from which a number of the patterns in this book have been taken, were produced for such specific ceremonial occasions as weddings and church visits **[59–61, 66, 92, 98, 101]**. The recurrence, albeit highly abstracted and geometric, of the tree, the horse, the giant, **[3]** and the reindeer in many Norwegian patterns has obvious roots in the fabric and routine of daily life in that country's densely forested landscape **[40, 53, 98]**. Further, these motifs are symbols whose origins can also be traced back to old Norse mythology: to the Yggdrasil, or tree of life, whose roots reach down to the underworld and whose top branches touch the heavens **[4, 46–48, 53, 75–77, 78–84, 104, 107, 115–16]**, and to the *bäckahästar*, the sea or river horses that lure unwary humans into watery trouble **[33, 58, 75]**.

These patterns, then, were used to adorn textiles, vessels, and other artifacts of everyday life. They were produced for and by the family. Until the seventeenth century there was very little large-scale production of such articles; they were

always part of much smaller, more intimate social units. In 1910, a correspondent for a London magazine recorded his impressions of Scandinavian rural life [5]:

[T]he everyday appearance of a Swedish peasant's home was chilling and still, but this appearance was altogether changed on the occasion of a festival . . . when the walls and ceiling were covered with woven or painted hangings . . . either of linen, woven, painted, or embroidered, or else of paper on which figures were depicted. The woven cloths were adorned with geometric designs, or with patterns of severely conventional floral motifs. . . . [A]mongst other things . . . were gaily-coloured coverlets and cushions, the patterns of which show how highly developed the peasant's sense of colour was, and to what degree of excellence this home-weaving industry had reached.

Scandinavia did not, of course, remain totally closed to Western European influences. Pattern books from Germany, France, and Italy began to be quite widely disseminated during the sixteenth and seventeenth centuries. Yet Yggdrasil and *båckahåstar* proved strong enough to survive all the vagaries of imported, foreign fashions.

5 *This photograph of the interior of a nineteenth-century Swedish log cabin gives some idea of the way in which locally produced decorative textiles were used in Scandinavia. The loom that can be seen in the right corner was probably in near-continual use.*

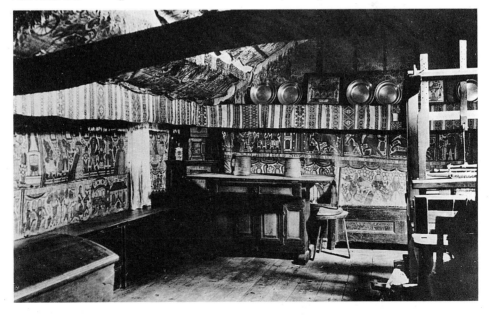

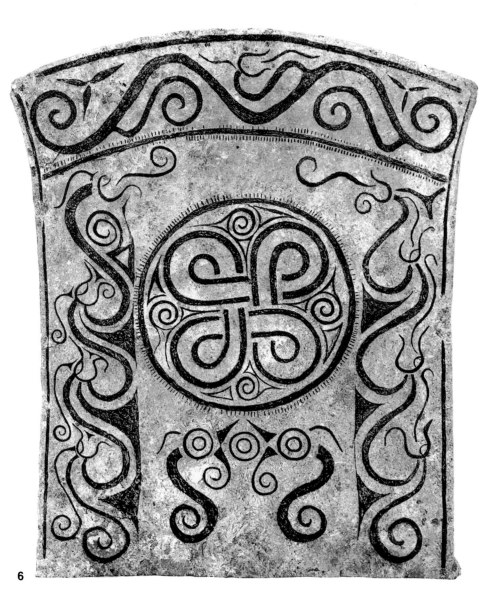

6

Swastika

6 ■ The swastika emblem appears in the center of this pattern, which has been derived from a fifth-century picture stone from Gotland, in Sweden. The Scandinavians believed the sign had magic properties and associated it with Odin, who as well as being creator god was god of magicians and seers.

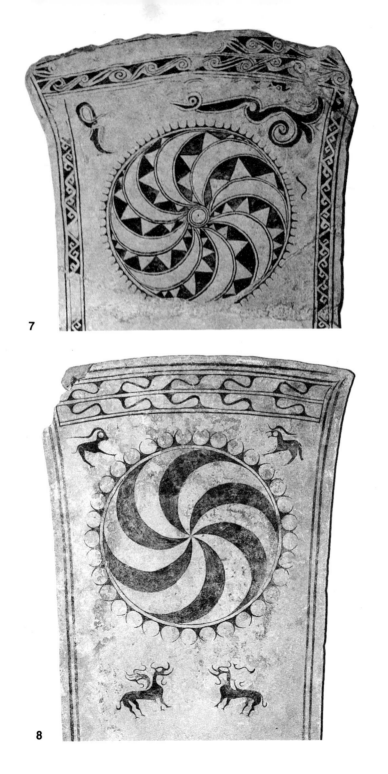

7

8

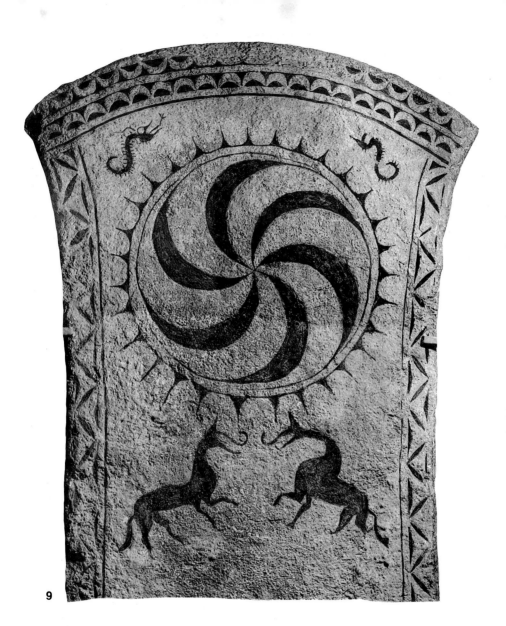

9

Solar disc

7, 8, & 9 ■ These three solar discs, or
sun symbols, have been taken from pic-
ture stones dating from the fifth and sixth
centuries, found in Gotland. Each is sur-
rounded by fabulous, mythical animals:
coiled serpents **[7]**, flamelike horses **[8]**,
and reindeer **[9]**.

10

Reindeer

10 ■ Before the arrival of Christianity, Scandinavian nomads decorated the skins of their drums with symbols of their gods and animals of the hunt, such as these reindeer. Only a few of the drums survive; most were destroyed by the church. The writer Ernst Manker traced these designs from some of the few that survive.

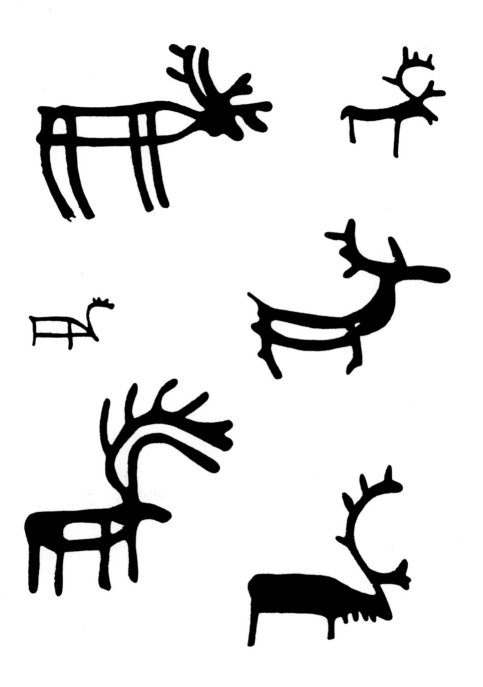

11

Weaves

11 ■ These five patterns have all been taken from ancient Scandinavian woven textiles dating from Viking and pre-Viking periods. The twill and dog's tooth patterns could date from Roman times. They have been found on fragments of clothing excavated in Norway and Denmark.

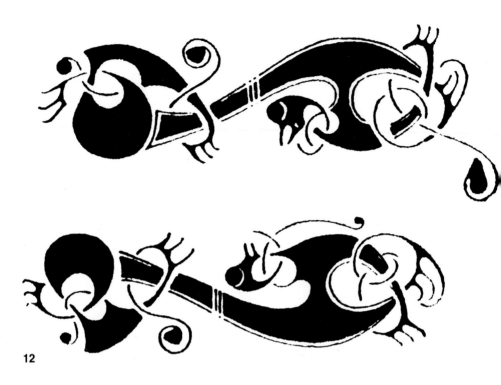

12

Broa

12 ■ This design and the following two are taken from a series of gilt-bronze bridle mounts found at Broa, in Gotland. They are among the earliest known Viking ornaments, probably dating from the late eighth or early ninth centuries.

13 ■ More compact than the first, this animal motif is similarly sinuous, with the body pierced at neck and hip. Tendrils are threaded through these openings. If the first motif seems serpentine, some of these second animal motifs are distinctly birdlike.

14 ■ This pattern is known as the "gripping beast" – an immensely popular and widespread motif that is known of from the Broa find but which persisted as the dominant motif in Scandinavian pattern until at least the eleventh century.

13

14

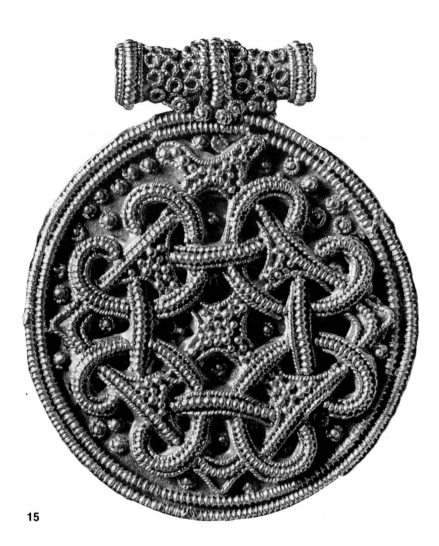

15

Borre

15 ■ "Borre" is another early style of
Viking ornament, dating from the ninth
century. An interlace pattern is made up of
a double ribbon arranged in rings and
loops. This example has been taken from
a gold pendant found in burial remains
excavated at Hedeby, an important Viking
trading center in Denmark.

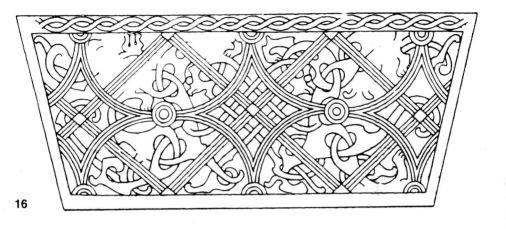

16

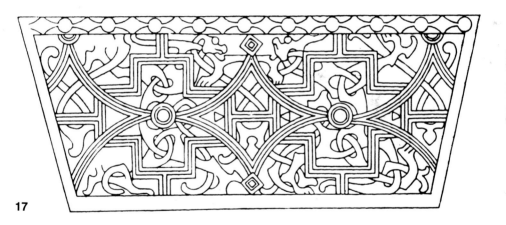

17

The Oseberg sledge

16 & 17 ■ These patterns are to be found on the front and back of the body of one of four eighth-century sledges found with a Viking ship at Oseberg in Sweden. Beneath a grid of geometric shapes lies a barely distinguishable pattern of interlaced animals. These would have been painted in red and black to make them more noticeable.

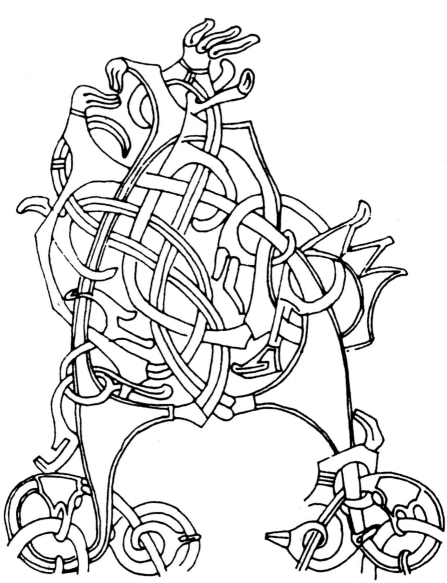

18

The Academician's animal-head bed post

18 & 19 ■ Among the other artifacts discovered at the Oseberg ship burial mound were four sets of eighth- or ninth-century carved wooden bed posts, all based on animal heads. The posts were intricately decorated. The restless, interlace pattern is based on a bird motif.

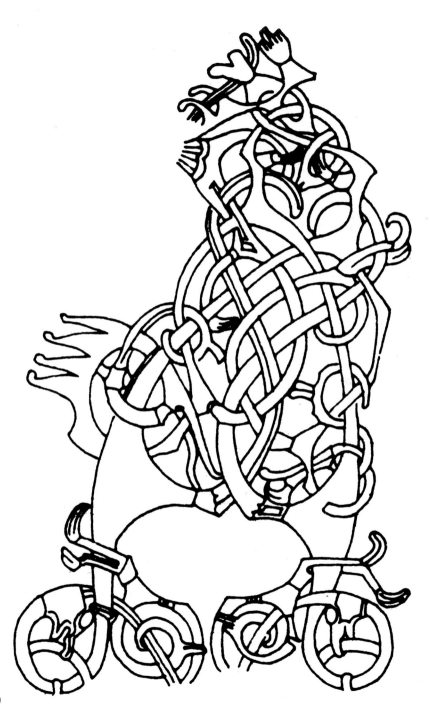

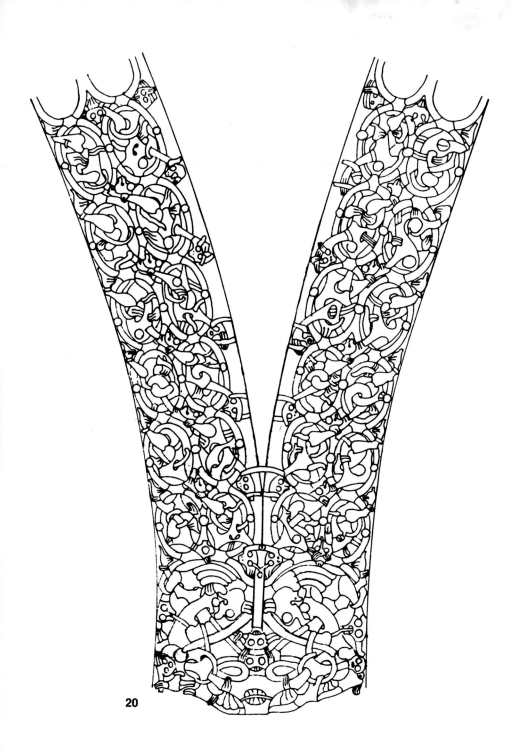

20

21

The Oseberg sledge

20 ■ This pattern is taken from the decoration on one of the poles from the Oseberg sledge **[16 & 17]**. As on the body of the sledge, the pattern here is built around a figure-eight animal body with a large dog's head.

The Baroque Master's second animal-head post

21 ■ Possibly slightly later than the Academician's bed post **[18 & 19]**, this pattern comes from one of the other wooden bed posts. Arranged within a framework of oval links, the carver here has based his pattern on the gripping beast motif **[14]**. But rather than depict whole animals, he has created his design using only disparate details – feet, tails, ribbons, and flaps.

22

Horse

22 ■ This simple but elegant design comes from one of the earliest surviving Scandinavian textiles. Fragments of a large, pictorial weaving were discovered at the beginning of this century at a ship burial just outside Oslo, in Norway. They date from the middle of the ninth century.

23

Check

23 ■ This banded, checkered pattern is also derived from woven fragments excavated at the Oseberg find. The burial mound was made for the Swedish Queen Åsa who died in the ninth century. This pattern was used on the leggings of a squire depicted in the textile.

24

25

Frieze

24 ■ Diamonds and crosses are combined in this more complex pattern, reconstructed by Sophie Krafft from the border or frieze of the Oseberg textile. All of the patterns derived from this source are highly geometric, but together seem to have been intended as a vivid testament to the variety of Viking textile design.

Key

25 ■ This elaborate pattern, dating from the ninth century, is also the work of Sophie Krafft [as are **22, 23,** and **24**]. The pattern centers on a motif that seems directly related to the Greek key design. Though little survives today, textiles were evidently important to the Vikings: One of the later saga writers in the thirteenth and fourteenth centuries imaginatively recorded how, in the early twelfth century, King Sigurd of Norway stupefied the Emperor of Byzantium with the magnificence of his silk fabrics.

27

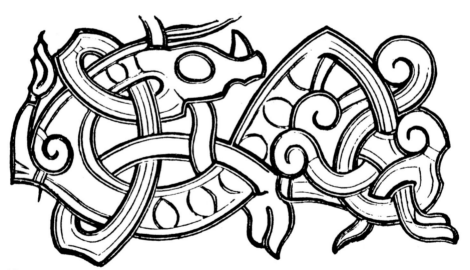

26

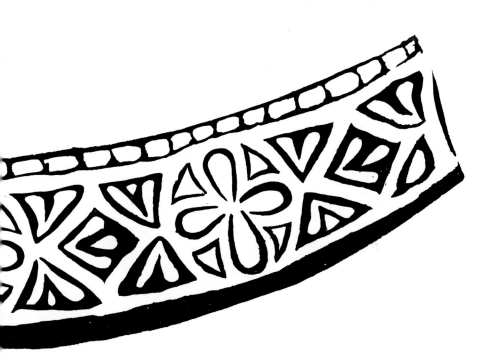

Jellynge

26 ■ Taking its name from a pattern that decorated a small silver cup found in a burial mound at Jellynge in Denmark, this is a slightly later style of Viking ornament that was used from the late ninth to the late tenth century. Its chief motif is that of a ribbon-shaped gripping beast. Jellynge-style patterns are a little more graceful and elegant than their Borre predecessors.

Trewhiddle

27 ■ This banded pattern is made up of alternate four-leafed plant and diamond forms. It has been taken from a double-edged sword pommel with silver plates, ornamented in "Trewhiddle" style dating from the ninth century.

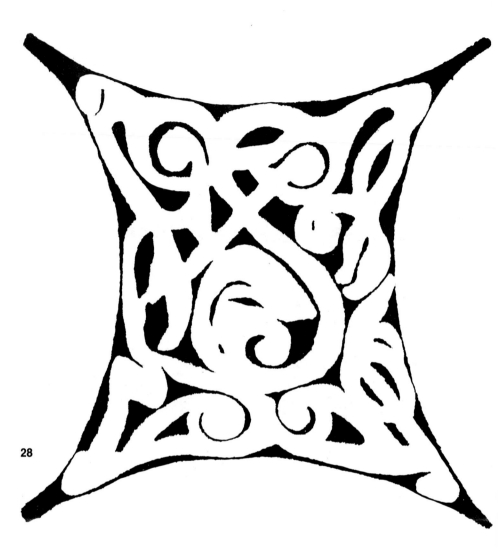

28

Asymmetry

28 ■ Viking craftsmen seem to have enjoyed creating patterns that suggest a symmetrical arrangement but which, in fact, end by confounding such expectations. This pattern has been taken from part of a rectangular brooch, probably from the tenth century, found in Denmark.

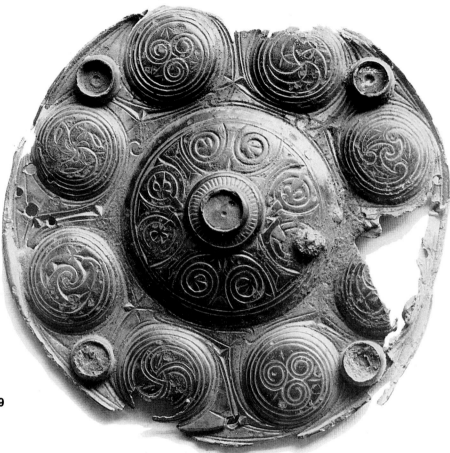

29

Ring
29 ■ The absence of any animal forms in the circular patterns of this tenth-century bronze buckle from Komnes, Sandsvaër, Buskerud, is indicative of the influence of Celtic artists working in Ireland. Ring forms, however, were particularly widespread in Viking ornament and only rarely seen in Celtic art.

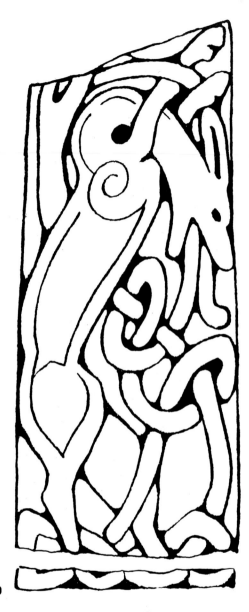

30

Cross

30 ■ This pattern derives from the carving of a stone cross that was found in the north of England. The animal and gripping beast motifs, however, reveal that it must have been carved by a Viking craftsman, for no animals appeared on Celtic crosses of the period.

Gaut

31 ■ Gaut was the name of a Norse stone carver working in the Viking-occupied Isle of Man in the tenth century. His work is distinguished by the integration of Celtic and Nordic motifs, as in the split, plaited bands of this pattern that has been taken from a stone cross.

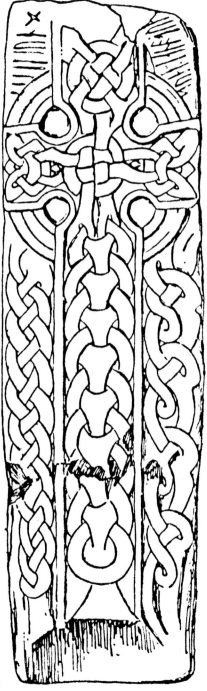

31

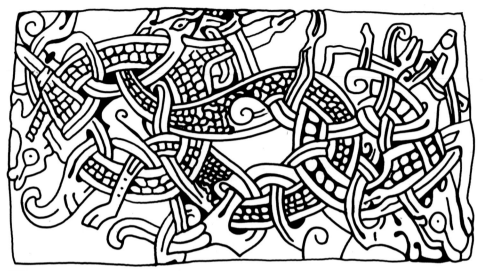

32

Mammen

32 ■ The name of this development in Viking tradition derives from a silver axe found in Mammen in Denmark. It seems to have grown directly out of the Jellynge style [see **26**]: the animal, however, is given more substance and, for the first time, is combined with curving plantlike tendrils.

Ringerike

33 ■ The Ringerike style was prominent in the eleventh century. It elongates the Mammen-style tendrils but also tends to subordinate plant forms to animal ones. The design has been taken from the gilded vane of a Viking longship; the beasts might represent the *bäckahästar* or horses of Nordic myth.

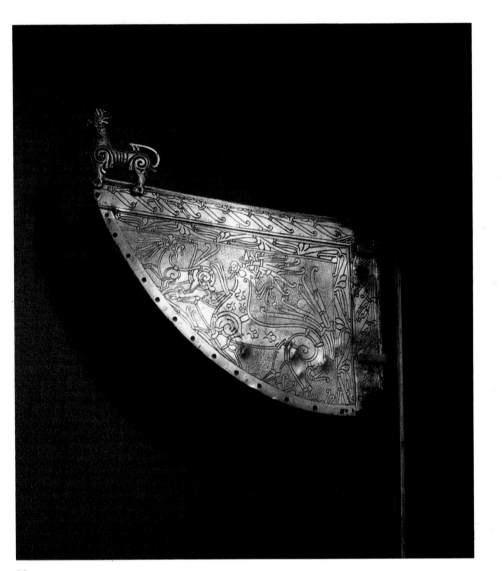

33

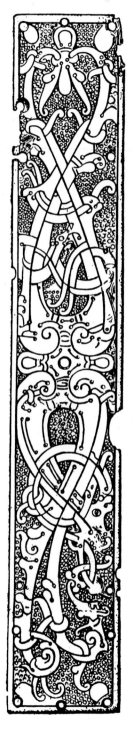

34

35

Ringerike
34 ■ Taken from a bronze panel now in Winchester Cathedral, this pattern probably also was originally part of a ship's gilded vane. Above the center, one of the main branches terminates as an animal head. At the corresponding point below, both of the branches are being eaten by a small snake.

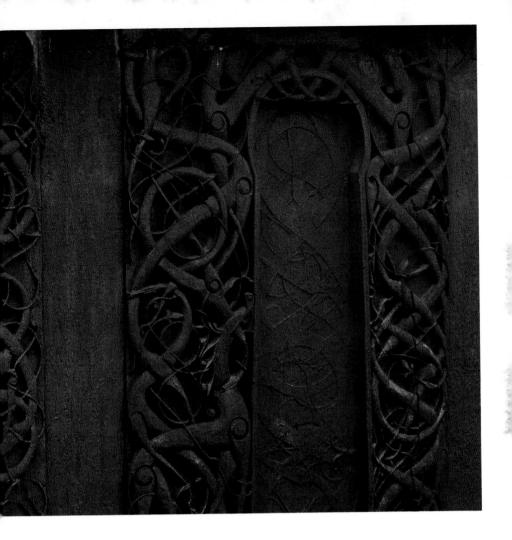

Urnes

35 ■ The Urnes style represents the final, most delicate and refined flowering of Viking ornament. It was extant only during the eleventh century. The name drives from the carved, wooden decoration of a church in the town of Urnes in western Norway, from which this pattern has been adapted.

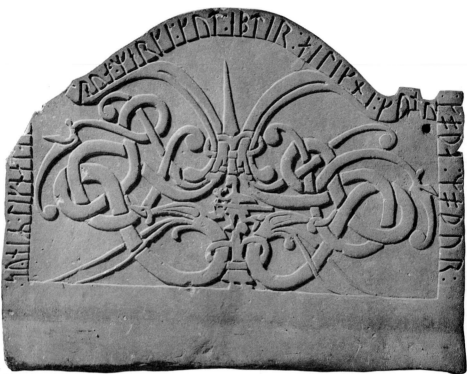

36

Urnes

36 ■ This example of Urnes style has
been taken from a late eleventh-century
gravestone from Gotland in Sweden.
Thereafter, the independence of Viking
ornament began to decline. During the
twelfth century, while the Scandinavian
nations drew closer to the rest of Europe,
their patterns began to show the influence
of Romanesque styles.

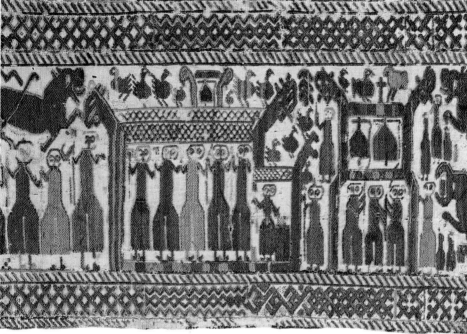

37

The Skog Church wall hanging

37 ■ The majority of Scandinavian medieval textiles have not survived. Many must have been destroyed – first when the advent of Christianity rendered pagan subjects undesirable, and second when ecclesiastical subjects were deemed blasphemous during the Reformation. This detail is from one of the few that has survived, found in a church in Hälsingland, Sweden. The three figures to the right are ringing bells to frighten off evil spirits and pagan gods, an indication of the tension that existed for many years between old religion and new. It has been dated by historians as having been made between 1050 and 1200.

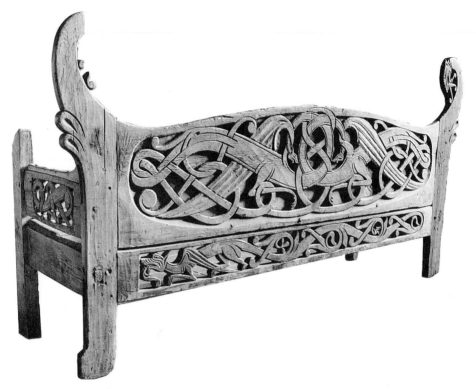

38

The Kungsåra bench

38 ■ This early twelfth-century bench from Kungsåra Church in Sweden was probably carved for a local lord or prince. Only the back, which would have faced the rest of the congregation, has been decorated.

The Rogslösa Church door

39 ■ A hunting scene fills the top section of this twelfth-century door from the church at Rogslösa in Sweden. Beneath it is a compressed version of the Fall, Redemption, and Last Judgment. The decoration is made of fluted and incised sections of wrought iron strapwork that have been riveted onto the wood.

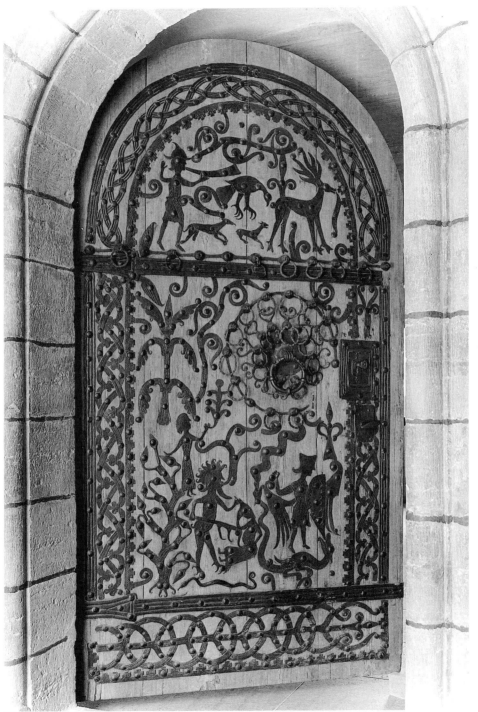

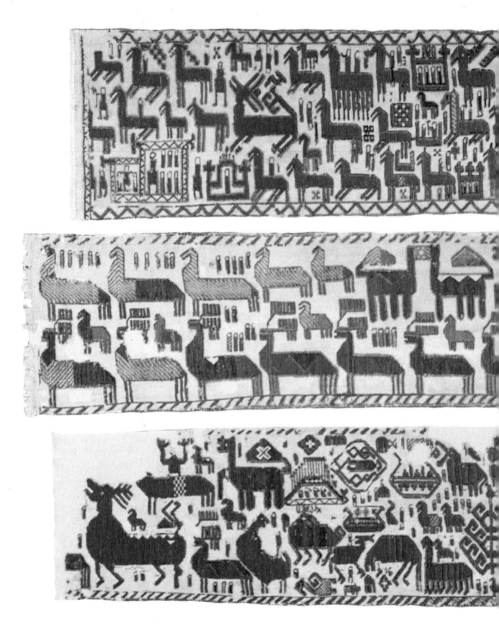

40

The Överhogdal tapestry

40 ■ The familiar beasts of Scandinavian mythology inhabit this doubleweave tapestry that dates from the Middle Ages and comes from Härjedalen in Sweden. Reindeer, crested birds, and horses and riders surround the stylized motif of the Yggdrasil. These ancient subjects were soon replaced by Christian ones.

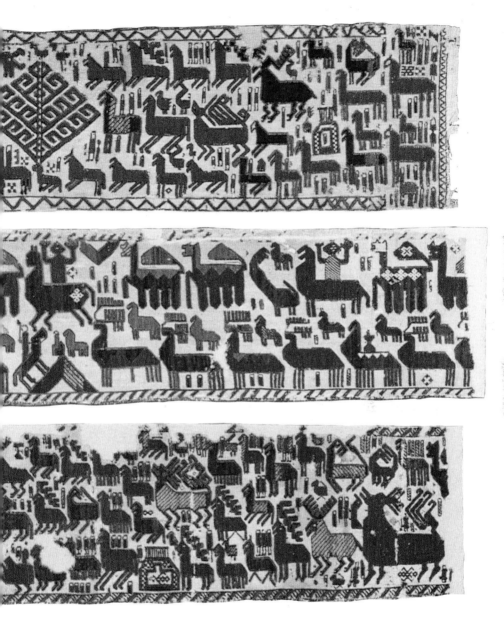

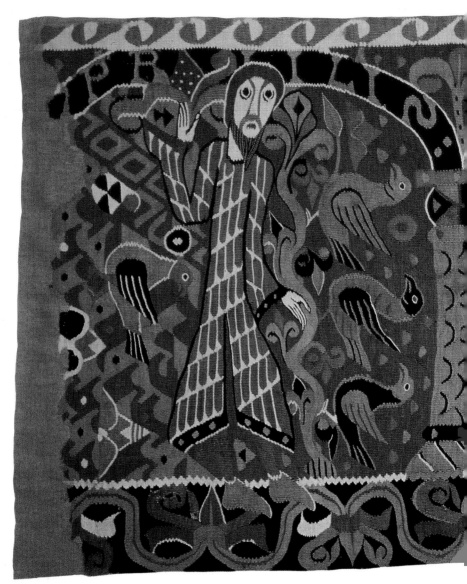

41

The Baldishol tapestry

41 ■ This fragment from a twelfth-century Norwegian tapestry was discovered in a church at Baldishol in the nineteenth century. The whole piece depicted the different months of the year.

The two figures that survive represent April and May. The wave motif in the upper border, as well as the acanthus leaf motif in the lower, reveal the influence of Romanesque designs.

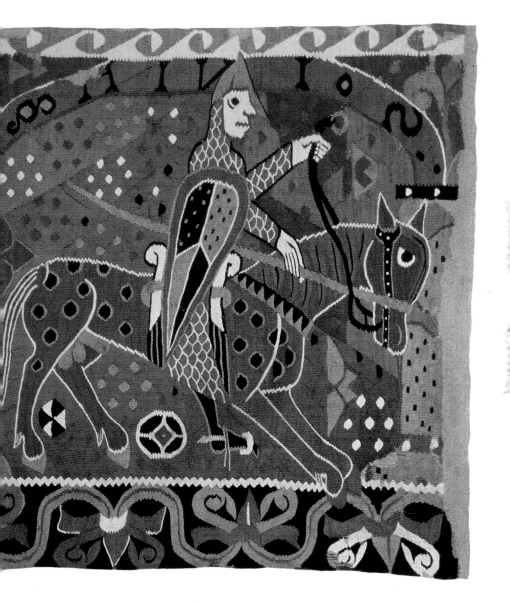

42

43

44

Three church roof beams

42, 43, & 44 ■ The roof beams of ancient Scandinavian churches, even the most humble, were often carved and painted in rich colors. These three, from churches in Sweden, were probably made in the twelfth century. The first **[42]** uses a flowing, interlace design originating from Viking ornament. The other two **[43 & 44]** include more complex floral and animal motifs – an indication of Scandinavian craftsmen's fascination with the new Romanesque and Byzantine patterns that were becoming increasingly popular throughout Europe.

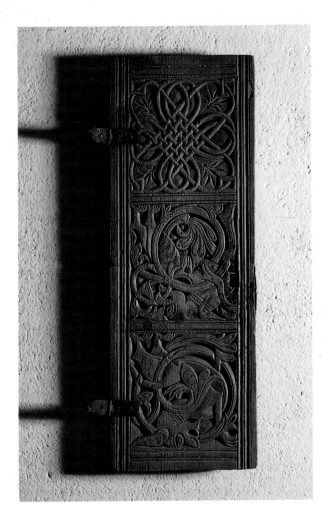

45

Lions

45 ■ Two lions, heraldic symbols of power, are set into square frameworks, their bodies and heads intertwined with ornamental tendrils. The pattern was carved in pine onto the door of a wooden cabinet found in Iceland. It probably dates from medieval times.

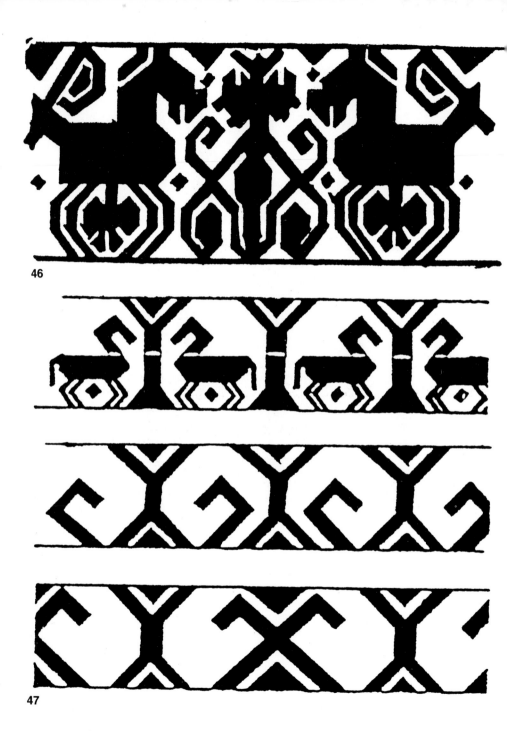

46

47

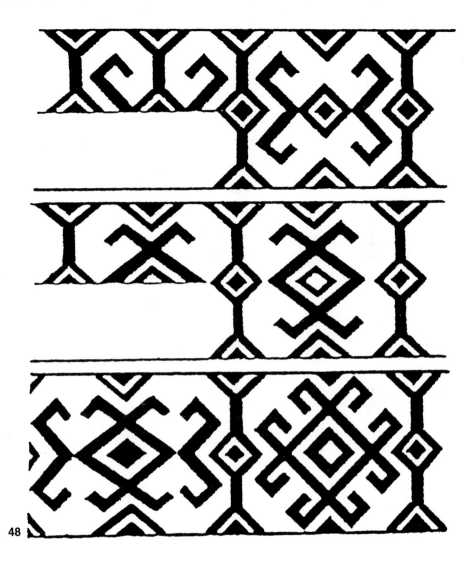

48

Horses and giants

46 ■ Two riderless horses face each other in mirrored poses in this medieval border pattern derived from embroidered clothing from the Karelia region in Finland. In between them, the traditional figure of the giant stands with arms raised. The motif, however, threatens to lose itself within an increasingly geometric schema.

Horse and tree

47 & 48 ■ The same motif lies behind each of these traditional, medieval Finnish patterns for embroidered border bands – a central tree flanked by two horses. When, however, the bands were widened and the pattern repeated in reverse beneath, their roots in myth and legend became difficult to recognize. Nonetheless, such roots probably underlie this widespread and peculiarly Scandinavian predilection for geometric patterns.

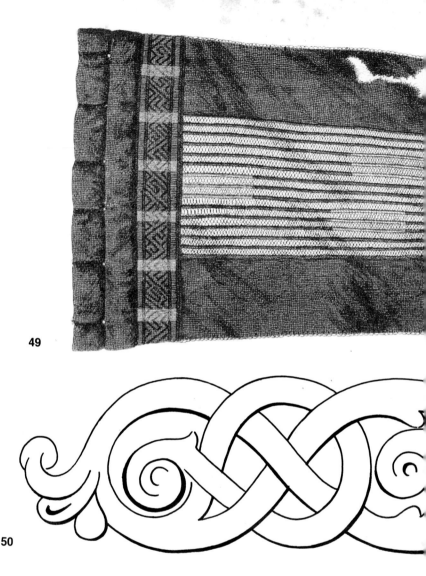

49

50

Key
49 ■ Taken from a fragment of a Danish medieval textile, possibly part of a woman's headdress, this pattern could be described as an elaborate variant on the traditional Greek key design. Trade connections between Scandinavian countries and the Eastern world make such an influence distinctly possible.

Romanesque
50 ■ This pattern is derived from the chancel decoration of an early medieval church in Jutland. Following the end of the Viking era, around the eleventh century, decorative procedures in Scandinavia began to adopt, albeit a little unsubtly, the Romanesque patterns that were widespread throughout the rest of Europe.

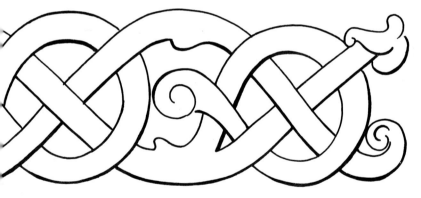

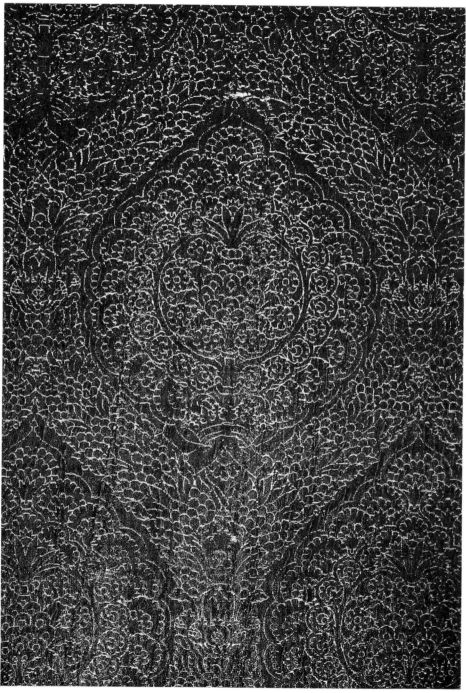

51

The golden gown

51 ■ This evidently Italianate pattern has been taken from the wedding dress of the fourteenth-century Swedish monarch Queen Margaretas. The central motif of a pomegranate, the symbol of fertility, was a graphic invocation for a blessed union.

Quatrefoil

52 ■ Two light quatrefoil frames form the dominant motif in this pattern from a mid-fifteenth-century altar fabric from Herrestad Church, in Gotland. The emergence of such a typically Gothic motif indicates a growing awareness among the Scandinavians of European developments, such as that fostered by Saint Birgitta in the late middle ages. She founded an influential textile school at the convent in Vadstena in Sweden.

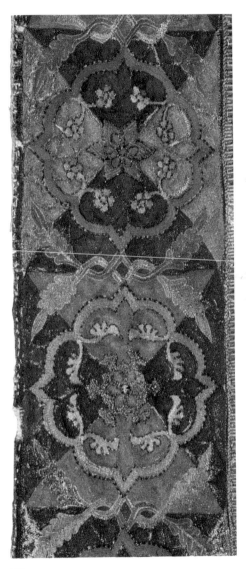

52

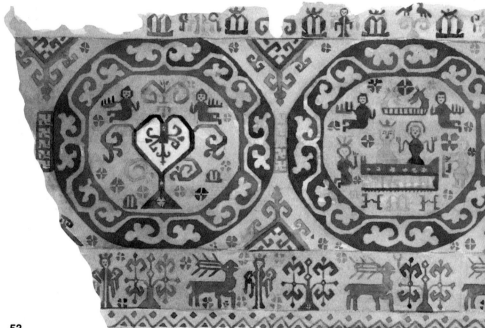

53

The Nådenals Abbey Church wall hanging

53 ■ Familiar motifs from Scandinavian mythology fill this watercolor showing a detail of a sixteenth-century (Finnish) wall hanging: the crested birds, reindeer, and the Yggdrasil. The central octagonal panels probably tell the story from some folktale or heroic sage.

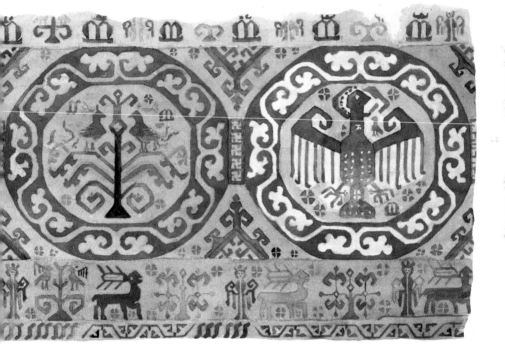

57

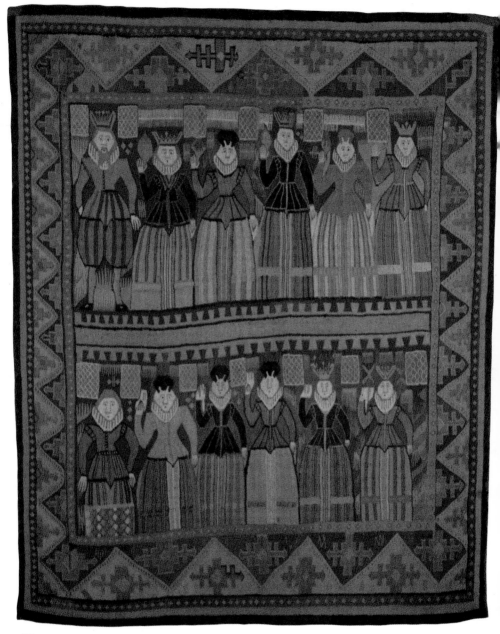

54

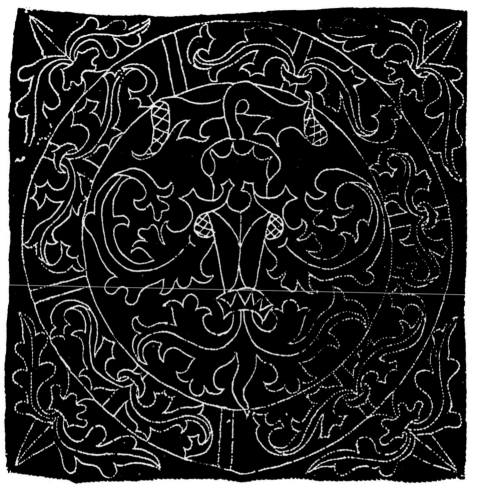

55

The wise and foolish virgins

54 ■ Dating from the Reformation, this cushion was probably made to celebrate a marriage. Both virgins and suitors sport sixteenth-century collars in a conscious effort to make the Biblical parable contemporary. Traditional pre-Reformation patterns, however, fill the border.

Gothic

55 ■ Gothic patterns had traveled as far north as Finland by at least the early sixteenth century. In this pattern from a panel of an ecclesiastical embroidery, made for the church in Kiir Kala, large flowers lie within the flowing, scrolled stems of a framing medallion. Branched leaflets fill the corners. Each panel seems to have been made up of fragments of old clothing that were sewn together before being embroidered with a gilt membrane strip.

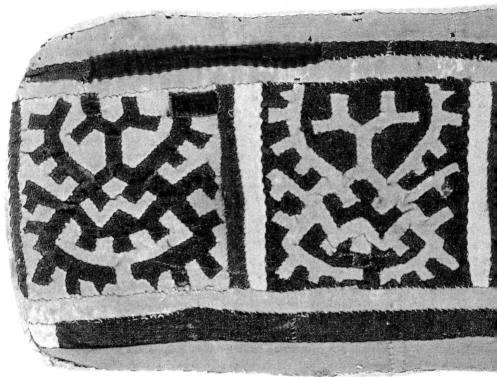

56

The North-Voguls saddle pad

56 ■ This pattern, probably from the sixteenth century, uses negative repetition, a common device where patterns were stitched onto woven supports and hung from the walls of a church or a house. The technique was popular because it saved precious material.

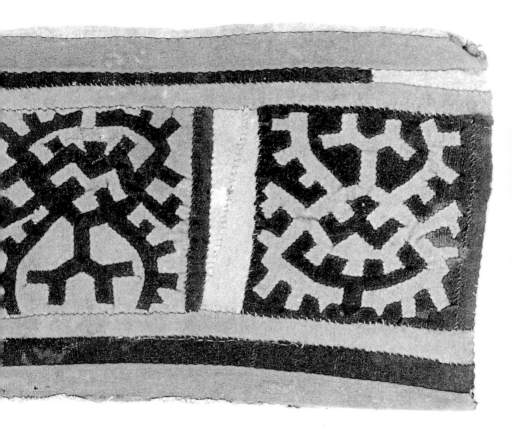

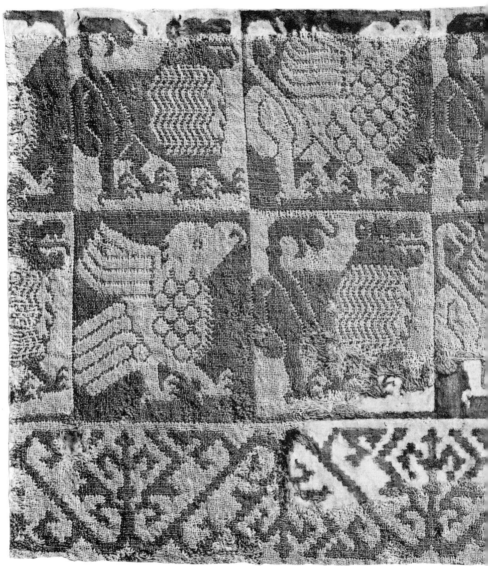

57

Evangelists

57 ■ Fabulous beaked birds and bearded lionlike beasts, each armed with jagged claws, alternate in bands in this design from a medieval Finnish church embroidery, probably sixteenth century. They could represent the traditional sym- bols of two of the evangelists – John (the eagle) and Mark (the lion). Another school of thought holds that they are heraldic animals, an important influence from Fin- land's earlier trading connections with Byzantium.

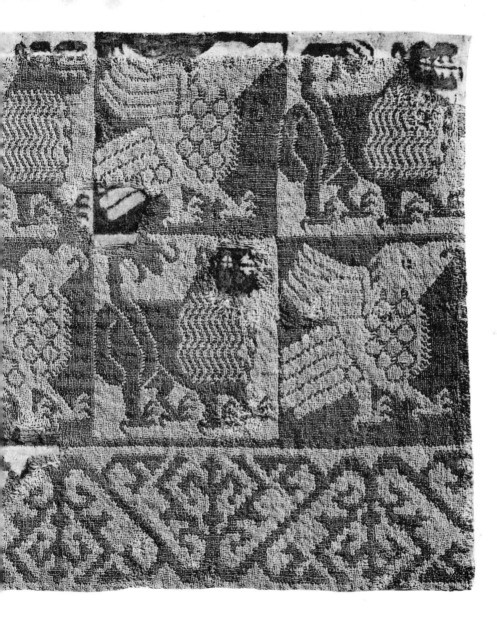

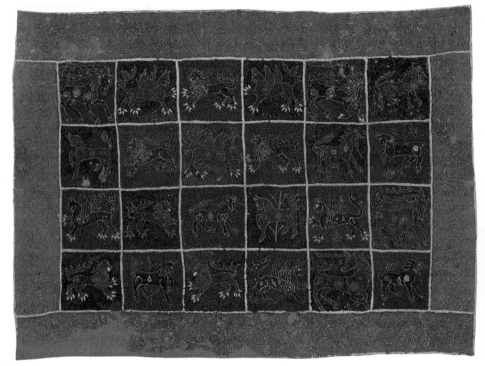

58

Negative

58 ■ Horses, dragons, and reindeer, doubled and reversed in the manner of an image and its photographic negative, fill the squares of this pattern. It has been taken from a sixteenth-century church hanging from Skepptuna in northern Sweden. It is extraordinary how long such ancient motifs as these continued to be used in ecclesiastic decoration.

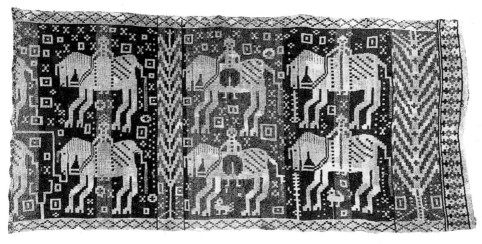

59

Bridal double-weave

59 ■ The bride with her crown, in the left-hand corner, leads a procession of riders in this fragment of a seventeenth-century double-weave textile from Kyr-kejebø in Norway. These articles were specially woven for the marriage ceremony and would have been part of a bride's trousseau.

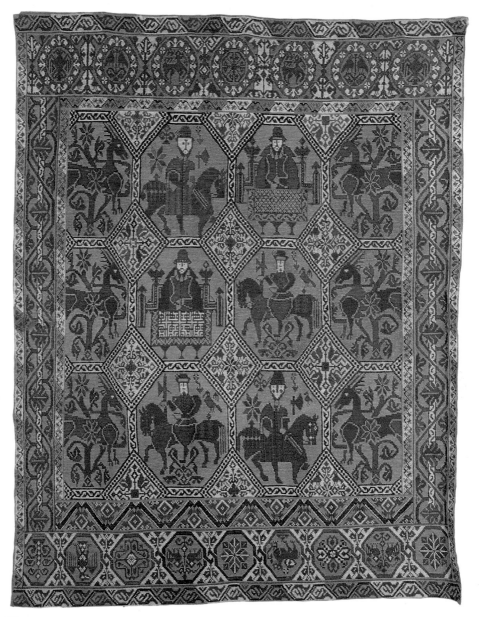

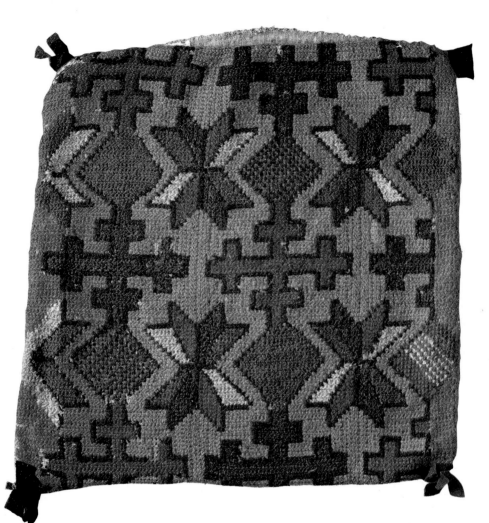

61

Riddarateppid (Coverlet of Knights)

60 ■ Each of the panels of this seventeenth-century Icelandic bed cover seems to relate to an episode of some lost saga or epic. The whole cover was woven in long-arm cross-stitch. Scenes of the hunt had magical associations for many Icelanders, with characters being led in and out of different adventures.

Eight-point star

61 ■ This design for a chair, carriage, or sleigh cushion was executed in long-arm cross-stitch, probably during the seventeenth century. The technique produced heavy, tapestrylike textiles that were very strong and durable. They almost always had geometric patterns. The eight-point star was one of the most widely used motifs of this time.

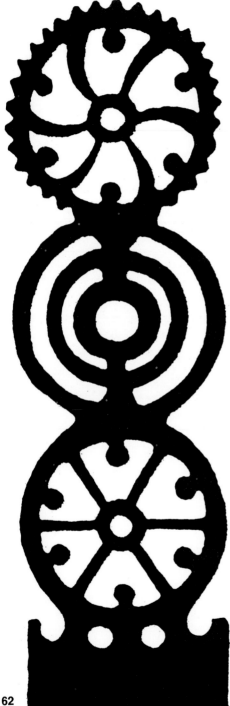

63

Solar disc

62 ■ Solar discs are an ancient motif found in many different cultures all over the world. These three variations are each derived from woodcarvings from a seventeenth-century Swedish church.

Arabesque

63 ■ The delicately executed forms of this floral motif have been taken from a seventeenth-century Danish silk embroidered tablecloth. The arabesque pattern has probably been adapted from a French original or modified from an imported pattern book.

62

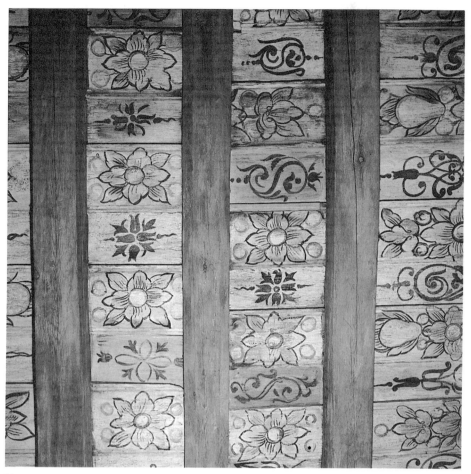

64

Maaling

64 ■ Examples of Maaling decoration, brightly colored patterns painted on domestic wooden furniture, originated in Norway at least as early as the late middle ages. These patterns were also painted onto wooden walls of domestic interiors. By the seventeenth century, the period from which this pattern dates, floral or fruit-based motifs tended to have displaced the geometric frames of earlier examples. The predilection for plant-based Maaling was probably stimulated by contemporary, imported European fabrics.

Bound Rose-Path

65 ■ Rose motifs were particularly popular in Norway and Sweden and can be found in textile patterns that date from medieval times. This pattern, probably from the seventeenth century, would have been either embroidered or woven onto the borders of tapestries or the sleeves of shirts, blouses, and jackets.

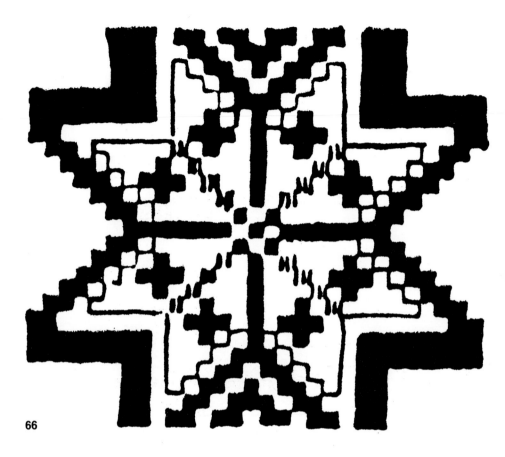

66

Rölakan
66 ■ A Rölakan was a type of double-sided, interlocked tapestry that was produced in the rich plains of southern Sweden. The tapestries, hung on the walls of peasants' and farmers' dwellings on special occasions, were highly colored and also displayed predominantly floral and geometric patterns.

Calligraphy
67 ■ Taken from a seventeenth-century mangle board of carved pine, this pattern has cleverly manipulated the letters of an inscription into an ornate, decorative format. Icelandic craftsmen were unique in western Europe for creating patterns out of the abstract graphic potential of letters of the alphabet.

Tendrils
68 ■ Gracefully carved tendrils from a seventeenth-century Icelandic mangle board curl and intertwine. The crisp detail and flowing rhythms testify to that island's strong native tradition in manuscript calligraphy, dating from the tenth century.

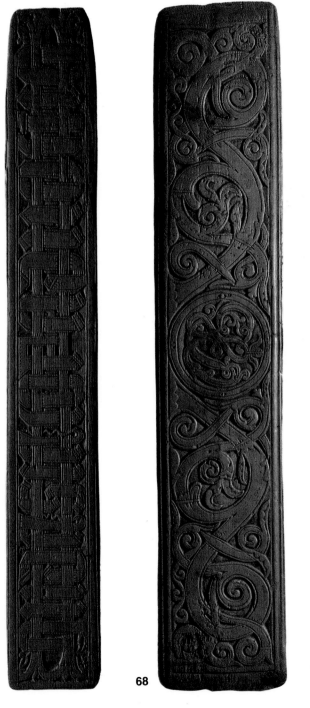

67 **68**

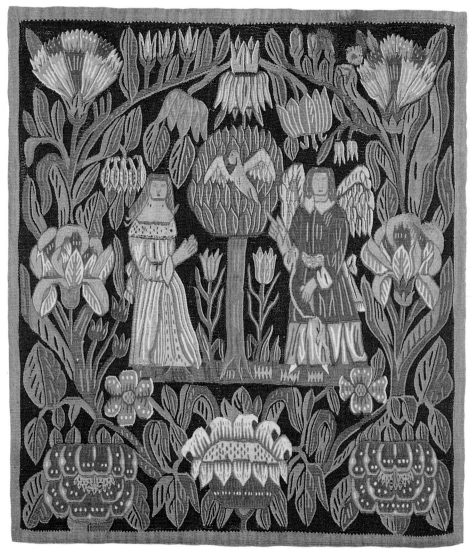

69

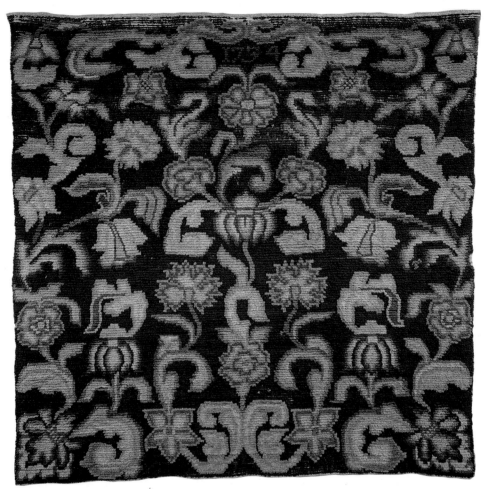

70

Annunciation
69 ■ This Scandinavian tapestry, which probably dates from the early eighteenth century, depicts an Annunciation scene. The angel points to a bird in a tree, possibly a pelican or heron, both of which had traditional symbolic associations with Christ's sacrifice and victory over death.

Rya
70 ■ Ryas are thick, double-pile rugs that date back at least as far as the tenth century A.D. Initially they were plain, but by the late eighteenth century Swedish women had begun to decorate them with designs from imported pattern books. This is based on French and German models.

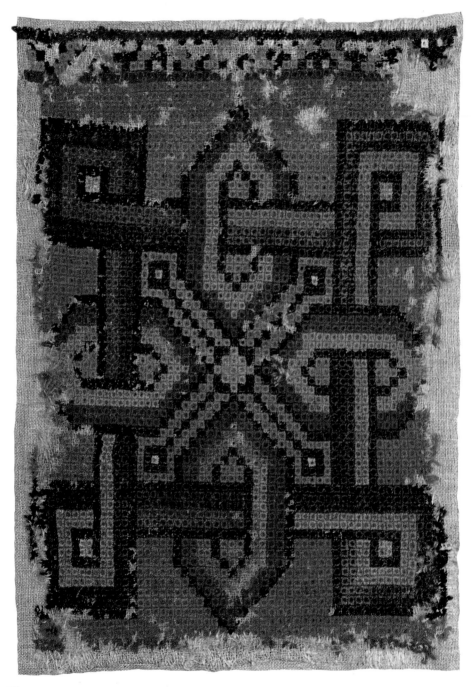

71

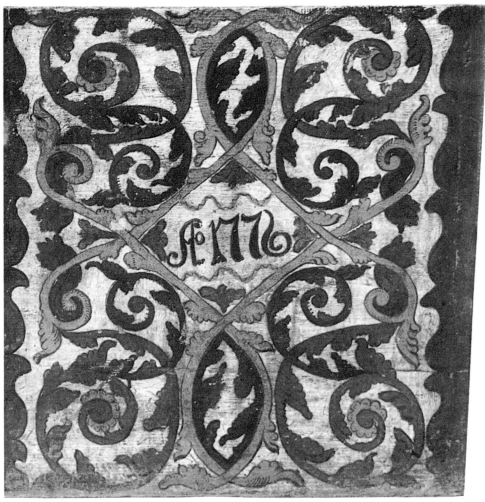

72

Geometry

71 ■ Many Scandinavian patterns are geometric, not only because the shapes and forms suited these people's expressive needs but also for technical reasons. Woven textiles, for example, were made on looms on which it was not possible to create curved or organic shapes. This pattern is taken from a fragment of an eighteenth-century Icelandic woven bed - spread.

Maaling

72 ■ This panel from a trunk made in 1776 is a fine example of a Maaling pattern favoring curved tendrils or plant-based forms that seem to be distantly related to earlier forms of decoration [see **45, 50, 68**]. Their deepest root may be in the Scandinavian countries' absorption of the Romanesque.

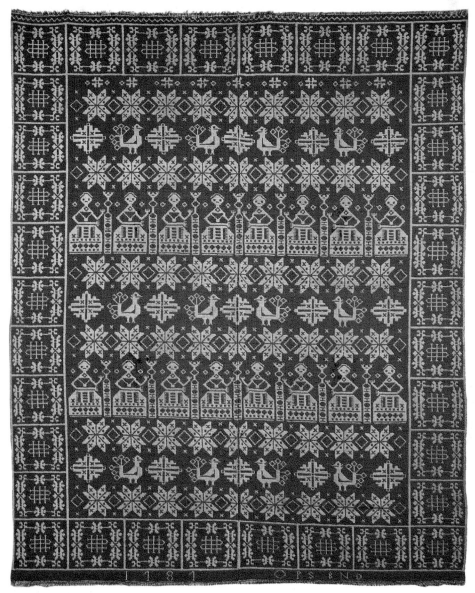

73

Figured double weaving

73 ■ This pattern, with its stylized bird, leaf, and female figure motifs, is characteristic of peasant variations of figured double weaving in "tabby" binding. It dates from a Swedish counterpane woven in Bohuslän, around 1787, by a farmer's wife probably during the winter when days were short and nights long.

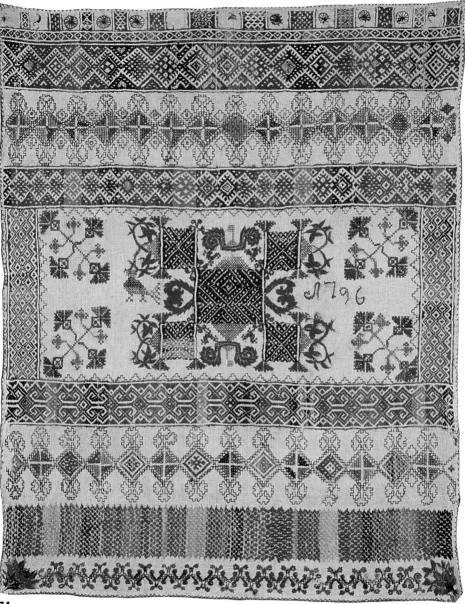

74

Coffin cloth

74 ■ This highly intricate and richly col-
ored wool embroidery, woven in Norway in
1796, was made as a cloth to be laid on a
coffin – to play a part in the social cere-
mony of funeral and mourning. The inclu-
sion of so many different motifs lends the
cloth an unexpected celebratory rather
than lugubrious note.

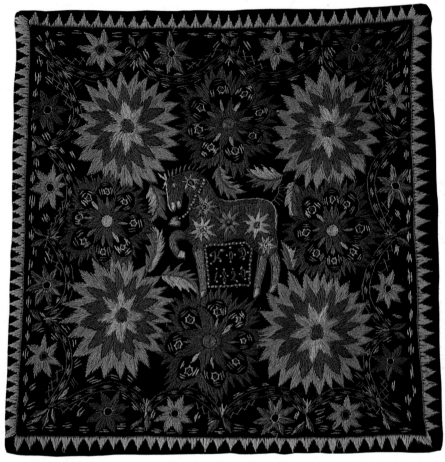

75

Bench cushion

75 ■ This pattern is taken from a twentieth-century copy of an original nineteenth-century Danish bench cushion. The original would, itself, have been based on older examples. The horse, one of the most ancient motifs in Scandinavian patterns, reappears here amid giant blooming flowers.

Rya

76 ■ This Finnish rya rug, made in 1820, is remarkable for the simplicity and highly abstracted nature of its design. Its stark geometry and bright color both seem to anticipate many more modern patterns.

76

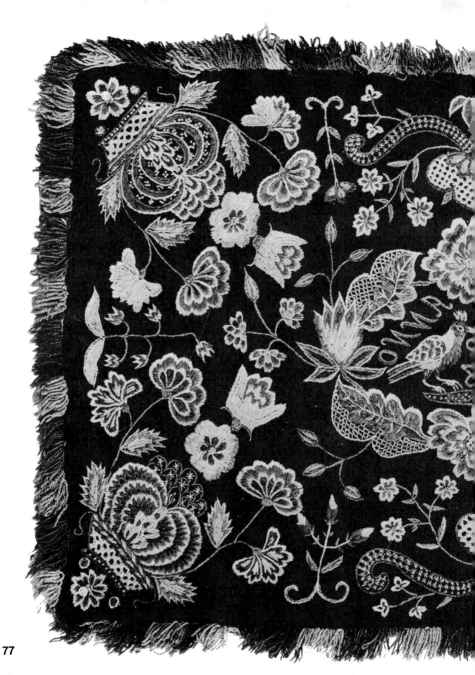

77

Baroque

77 ■ Two crested birds face each other in this design taken from an early nineteenth-century Danish embroidery. They are surrounded by a panoply of blooms and tendrils. These motifs are traditionally Scandinavian. However, they

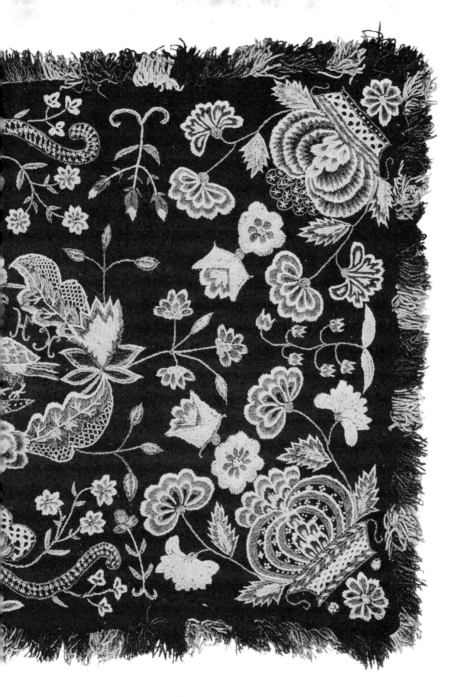

have been naturalistically described – an
indication of Baroque French or German
influence prevalent at the time.

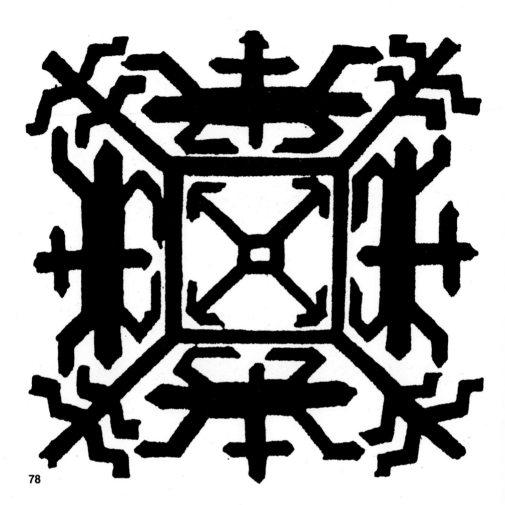

78

Horse and tree

78 & 79 ■ The familiar motifs of horse and tree were adapted for the square format of the embroidered chests of two traditional blouses, from the Tchouvache district of Finland in the nineteenth century. Here, double-headed horses, each sharing one rider, are separated by the diagonal accents of the tree. Extreme thematic limitations evidently fostered the wide variety of decorative patterns.

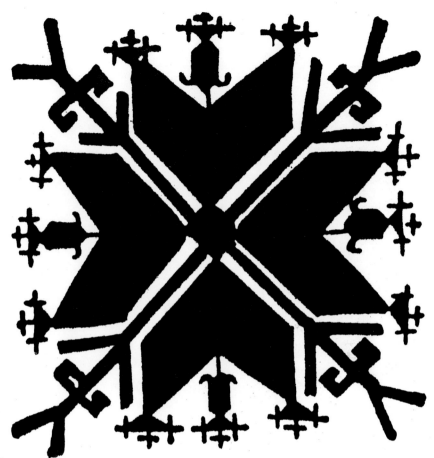

79

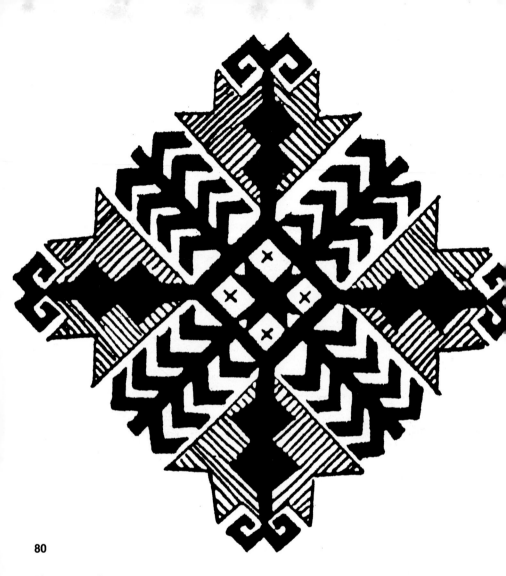

80

Horse and tree

80 & 81 ■ These two squared patterns, also adapted from nineteenth-century Finnish blouses from Tchouvache, use the tree motif as the main diagonal form. The horses seem momentarily to have disappeared. For all their variety, however, the women who invented these patterns never departed from their ancestors' commitment to the geometric and abstract.

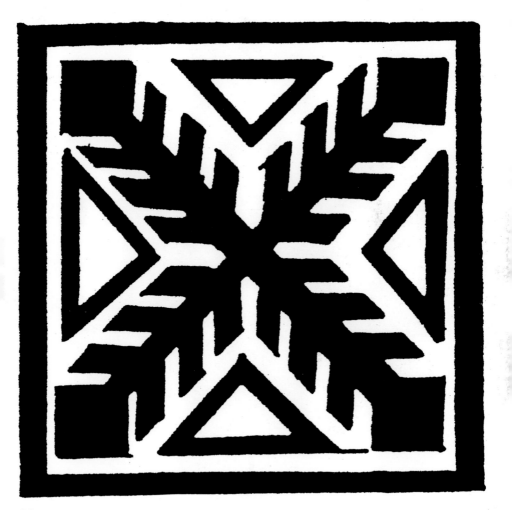

81

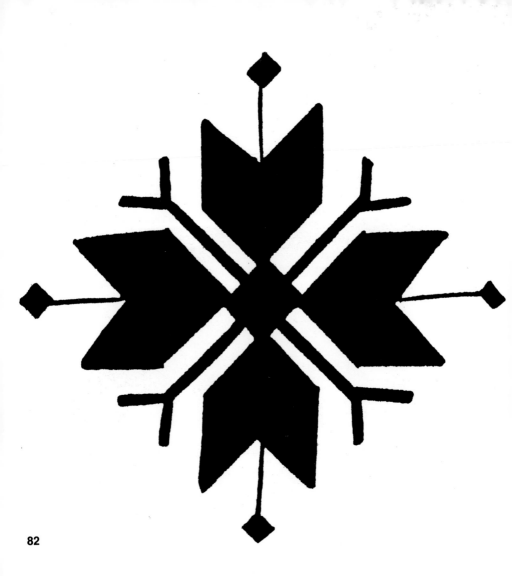

82

Horse and tree

82 & 83 ■ Faint vestiges of the tree and horse are discernible in these two Finnish patterns, again taken from the embroidered chest pieces on nineteenth-century blouses. We will never know for sure whether the women who designed these patterns were aware of their roots in ancient myth.

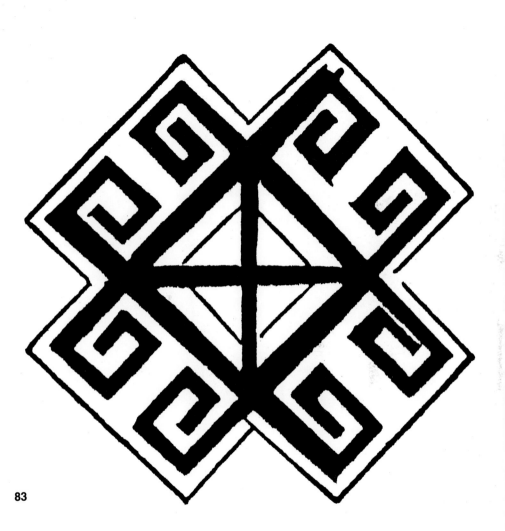

83

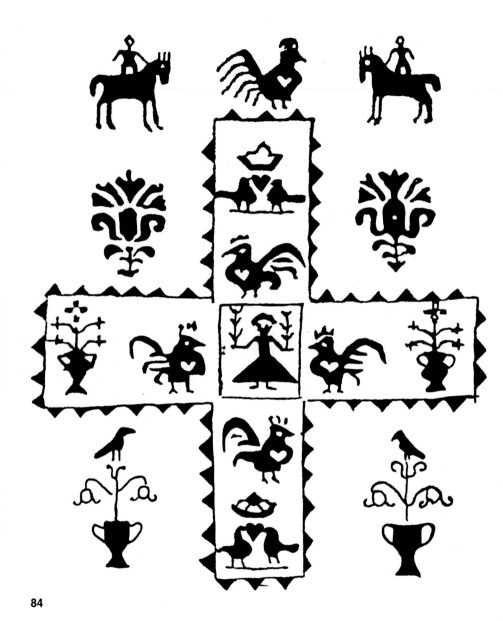

84

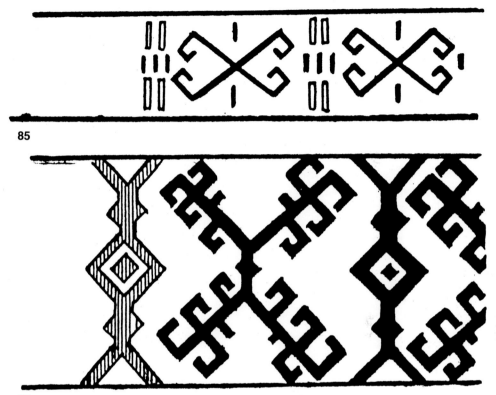

85

86

Amalgam
84 ■ An amalgam of favorite mythic Finnish motifs has been arranged around an equal-sided, bordered cross. They include horse and rider, cockerels, and crowned love birds. This pattern too derives from a nineteenth-century embroidered blouse. The central female figure might possibly represent Freyja, the goddess of plenty and prosperity.

Horse and tree
85 & 86 ■ The double or mirrored horse, as well as the tree, appears again in the Finnish patterns used here on the embroidered borders of peasant blouses, from which this design is taken. The design also incorporates the ancient swastika motif [see **6**], traditionally associated with magical invocations of the blessings from the Scandinavian gods.

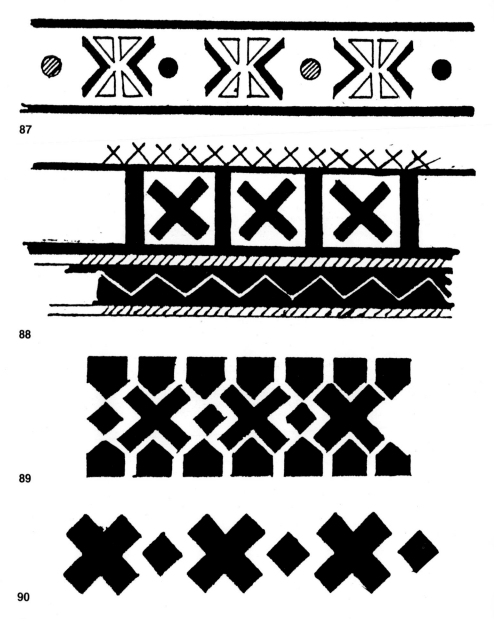

87

88

89

90

Cross

87, 88, 89, & 90 ■ These variations on a basic cross motif have been taken from nineteenth-century Finnish folk embroidery. They would have been used on the borders, sleeves, and seams of homespun garments. The Finnish craft tradition, and this distinguishes it from that of the other Scandinavian countries, has always enjoyed decoration for its own sake, perhaps by virtue of its extremely close contacts with its powerful neighbor Russia and eastern ornamental influences.

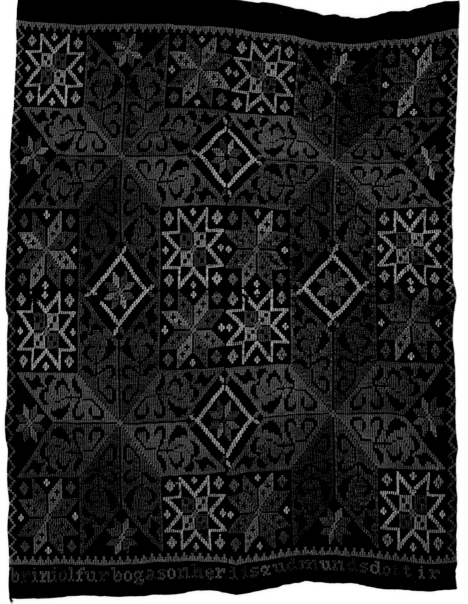

91

Star

91 ■ Tendrils and abstracted flower motifs fill this star pattern. Star shapes on dark backgrounds were particularly popular in Iceland, and this design is based on a nineteenth-century Icelandic bedspread. Such textiles would often provide the only touch of color within the spartan interior of the house.

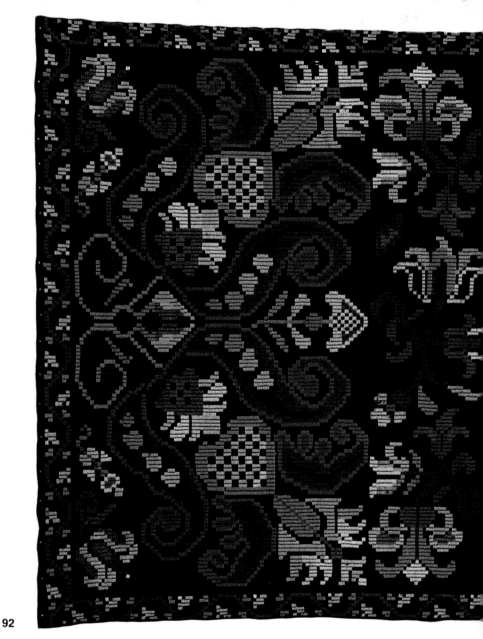

92

Saddle cover

92 ■ This pattern has translated the organic curves of a floral motif into geometric terms. It has been taken from a nineteenth-century Icelandic woven cloth saddle cover, and would probably only have been used on specific ceremonial occasions such as weddings or specially important church visits.

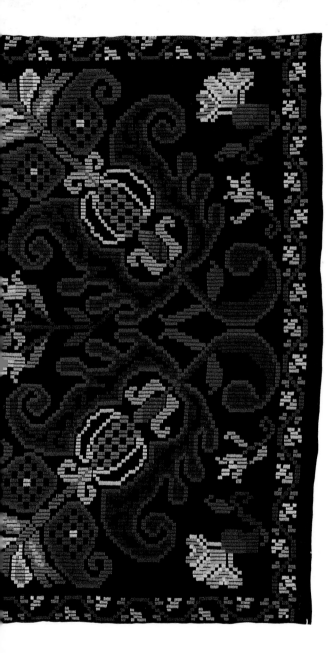

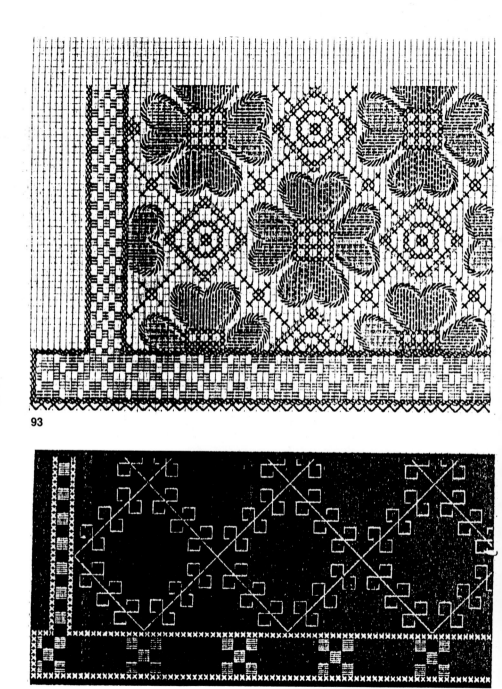

93

94

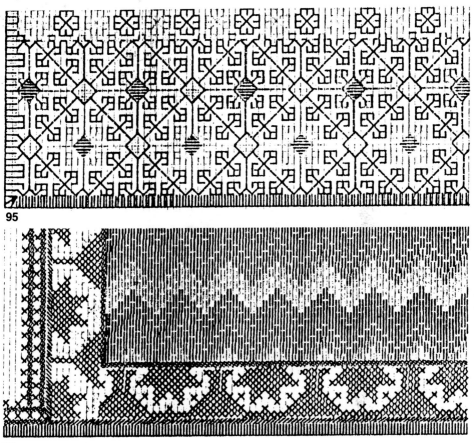

95

96

Revival

93, 94, 95, 96, & 97 ■ These five patterns are among many traditional woven and embroidered designs from Finland that were collected and published in the late nineteenth century. The first **[93]** is obviously floral in inspiration, but unusual in that it eschews the geometric treatment so integral to Finnish patterns. The second and third **[94, 95]** both use the swastika motif as a point of departure. The swastika, despite its present associations, traditionally symbolized invocation of blessings from the gods and can also be found on Viking burial inscriptions. The fourth **[96]** derives from embroidered borders, a design with a simple, basic form

97

manipulated to produce a subtle and intricate pattern. The fifth **[97]** is a Finnish variant on the widespread Swedish Vigg, or lightning pattern.

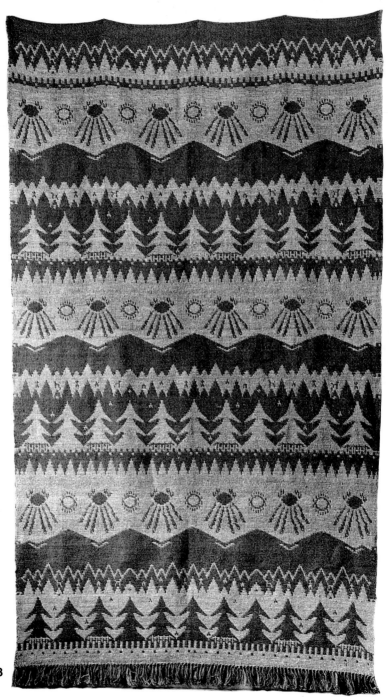

98

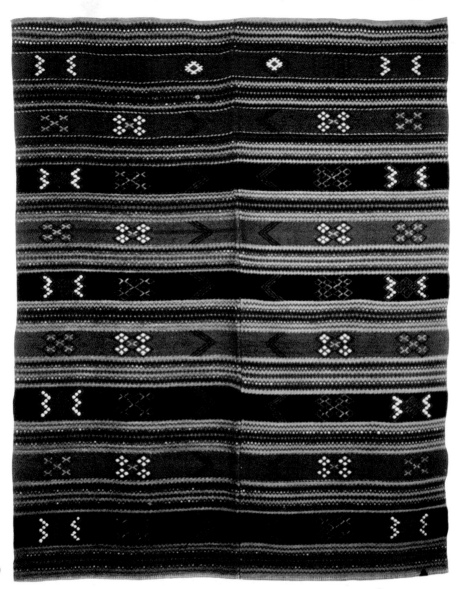

99

Landscape

98 ■ Sun and moon shine down, side by side, on the endless ranks of pine trees beneath a horizon of mountain peaks in this design taken from a Finnish "Tåkånå" tapestry. It would have been boldly colored and hung in the home on special occasions.

Diamond

99 ■ Diamond lozenges variously arranged in clusters on a monochrome background, and aligned in horizontal bands separated by stripes, is a pattern found on rugs and tapestries throughout Finland. The colors would have been made from natural dyes.

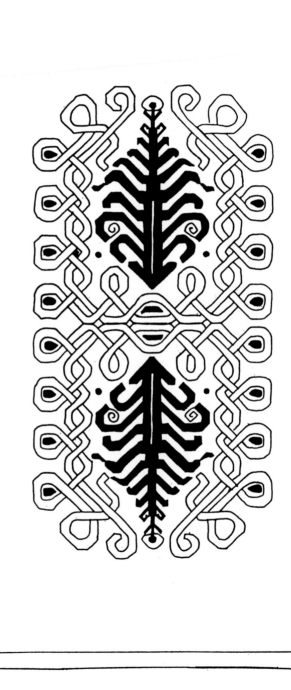

100
Tree
100 ■ This old pattern is taken from a nineteenth-century Finnish woven tapestry. A bold, lone, and drastically stylized pine tree forms the central motif, surrounded by an angular interlace design. Mirrored patterns such as these were known as "Moskve," an indication of the Finns' close contacts with Russia.

101

Eight-point star

101 ■ Traditionally, Scandinavian brides made and embroidered large, billowing shirts for their husbands. These were decorated on collar, cuff, and front placket. This eight-point star pattern is taken from a cross-stitched band from Telemark, in Norway.

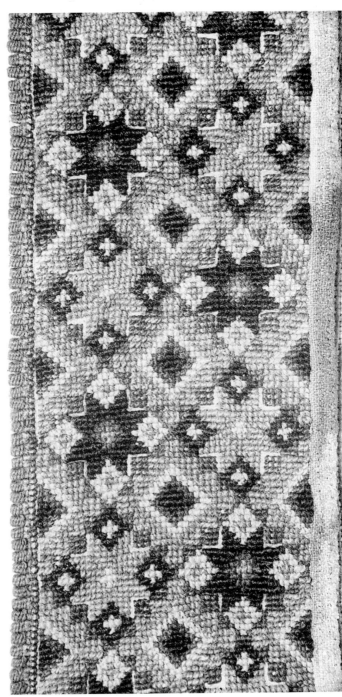

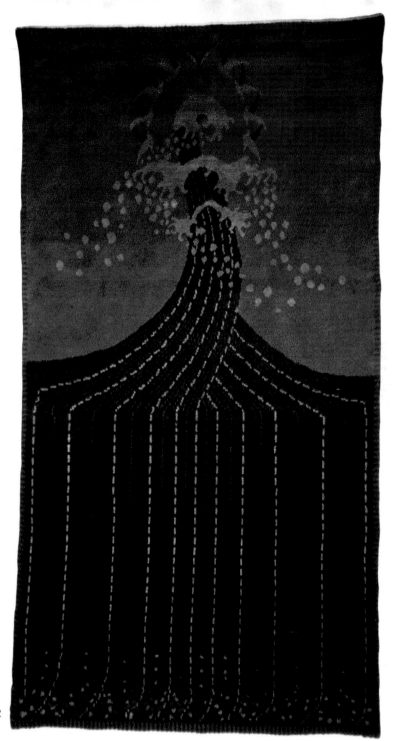

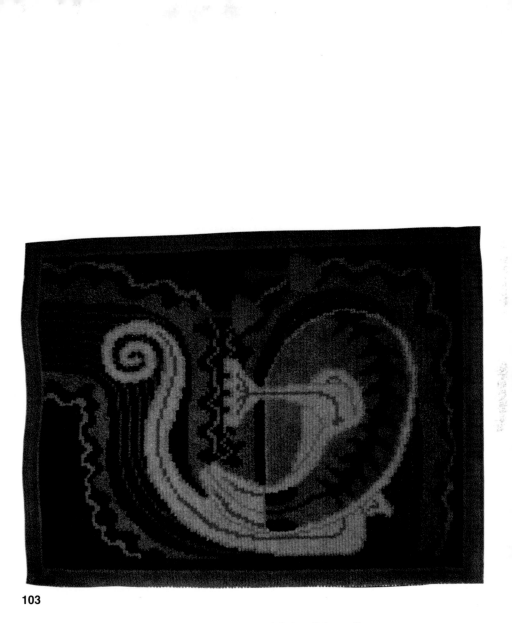

103

Lokki (Gull)

102 ■ The sinuous curves of Art Nouveau inform the rhythms of this early-twentieth-century Finnish rya rug designed by Jarl Eklund. However, the muted color scheme of black, brown, and white looks back to previous ages, before wool was dyed.

Lisko (Lizard)

103 ■ Designed by Finnish textile artist Aksel Gallen-Kallela in 1904, this rya rug depicts a scene from the *Kalevala*, a national epic poem. On the banks of the River of Death sits a lizard, its long tail nestling among sharp and bloody rocks.

Nursery

104 ■ This twentieth-century pattern, a somewhat simplistic and representational design of alternating reindeer and trees, derives from a 1930s adaptation of a traditional Danish nursery hanging. It stems originally from an eighteenth-century pattern book.

Stocking

105 ■ This pattern, also adapted from traditional sources in the 1930s, is taken from the fragmentary border of what seems to be an eighteenth-century stocking found in a remote fishing village in Jutland, Denmark.

Shawl

106 ■ In the past, Danish mourning shawls, though sober in color, did include small areas of decorative embroidery. In the Reformation, however, such frivolity was banished and the shawls became purely black. Old patterns such as this one were later resuscitated, as for example in this 1930s design.

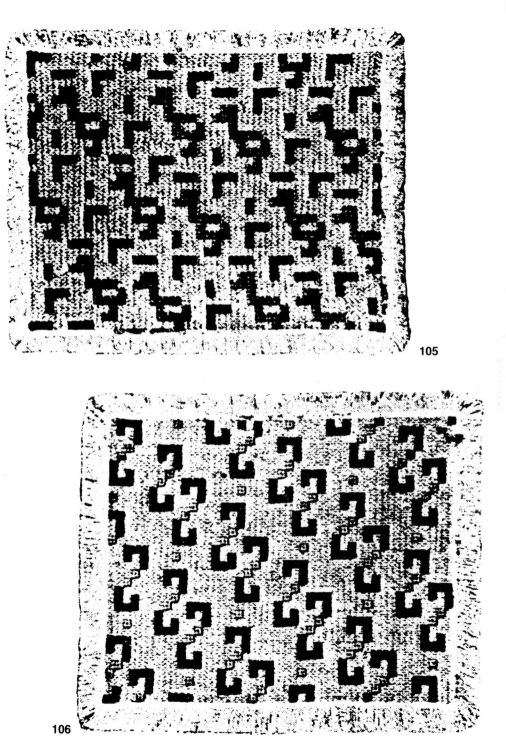

105

106

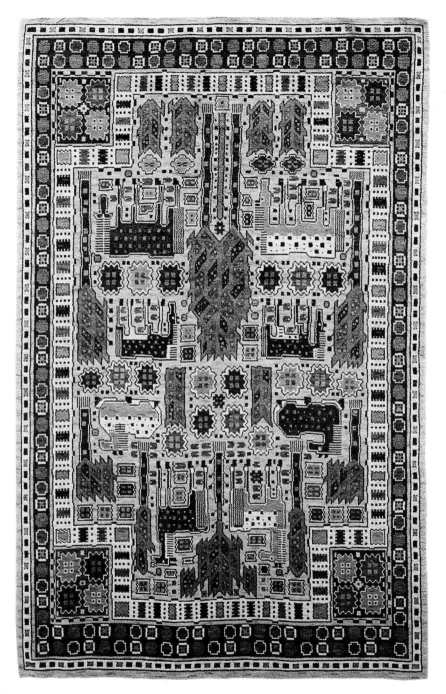

107

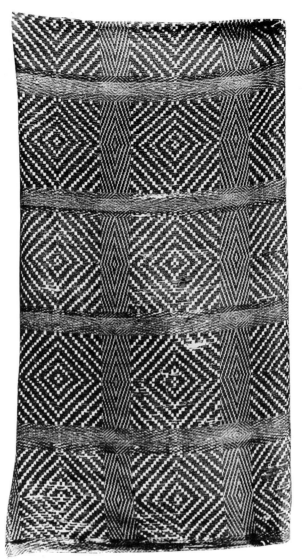

108

Horse and tree

107■ Until her death in 1941, Märta Määs-Fjetterström was one of the most influential of a number of pioneering twentieth-century Swedish weavers. She sought to keep alive traditional weaving techniques and designs, such as the horse and tree motif seen in this Scandinavian pattern, one of the most enduring.

Lozenge twill

108 ■ This woolen rug was made in Sweden in the late 1920s. The pattern has been described as lozenge twill and has been found on fragments of textiles that date from pre-Viking times.

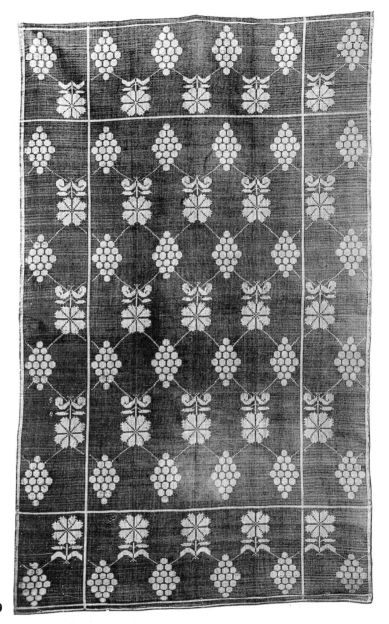

109

Vine

109 ■ This simple vine pattern was de-
signed by the Finnish textile design Eva-
Stina Dahlqvist in the early 1930s. It was
produced for fine damask fabrics used for
domestic purposes. Despite the Bac-
chanalian theme, the design is character-
ized by elegance and austerity.

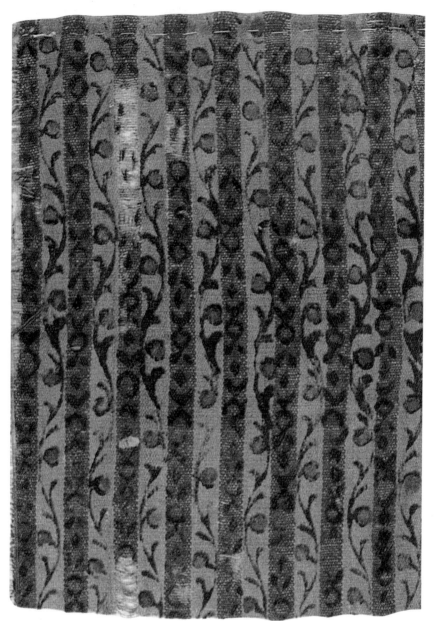

110

Needlethread

110 ■ This Finnish needlethread pattern was embroidered onto a simple, striped woolen bedspread, in 1932. The pattern was never used commercially, but pro- vides another example of the way in which traditional handcrafted designs with centuries-old origins have survived into the present century.

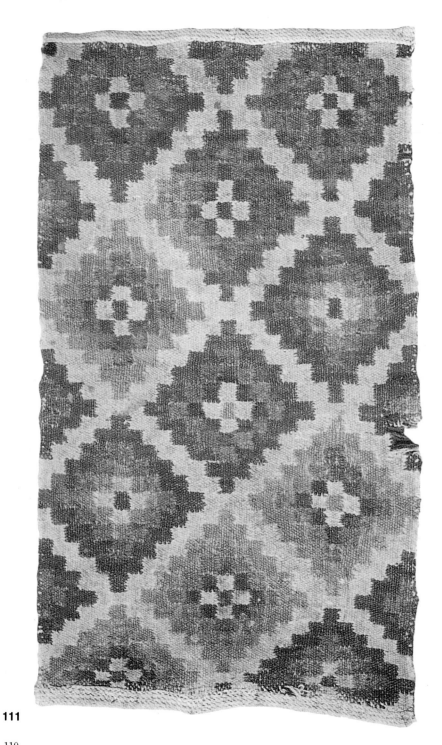

111

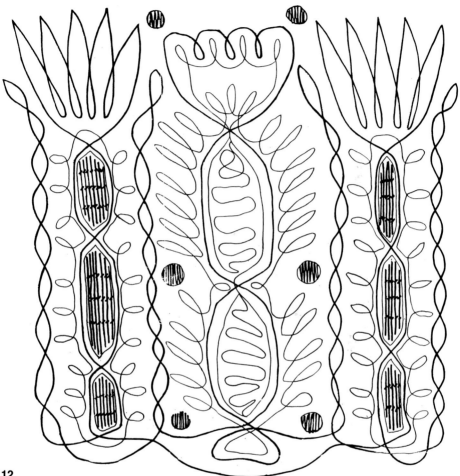

112

Frieze

111 ■ This Swedish rölakan, or double-weave rug, was woven during the 1930s. It would have been produced in the home. The pattern has survived more or less unchanged since Viking times [see 24].

Stem and flower

112 ■ Within a square format stand three highly stylized plant forms, each crowned with a flower. Stem and flower alike are linked by two separate but mirrored threads of interlace in this modern adaptation of a traditional Finnish embroidered pattern.

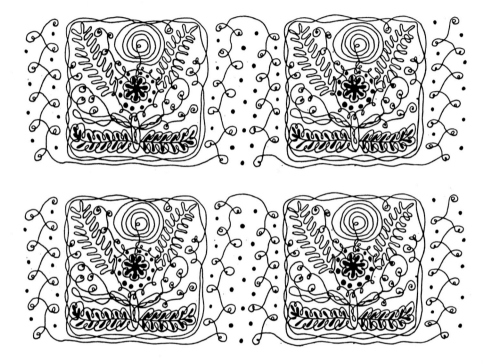

113

Flowers and leaves

113 ■ Not all Scandinavian patterns, even the most ancient, are geometric. In this 1950s adaptation of a traditional border motif from a Finnish woven tapestry, a nervous line freely describes flowers and leaves within a loose square framework. Each square is surrounded by an equally spindly interlace pattern.

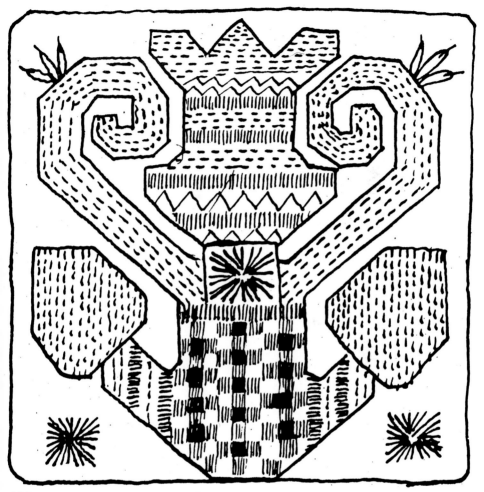

114

Finnish traditional

114 ■ It is not certain, in this 1950s adaptation of an old Finnish motif traditionally embroidered on cushions and rugs, whether the form has roots in the human or animal world. Its similarity to certain traditional Swedish patterns suggests common sources in Asian or perhaps Byzantine textiles.

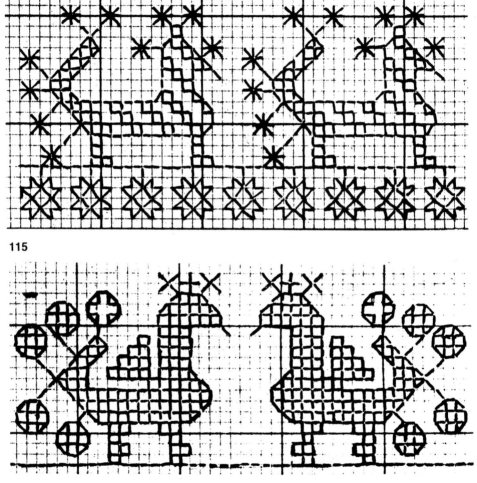

115

116

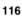

114

117

Birds

115 & 116 ■ In these two patterns, adapted from the 1950s from an old Finnish lacework, the ubiquitous crested bird makes another appearance. In Nordic mythology a cockerel was said to perch at the top of the Ygddrasil to warn the gods of the approach of the belligerent race of giants.

117 ■ Mirrored pairs of birds with outstretched wings share a diamond-shaped head. Each pair is separated by a ten-branched star. This pattern has been taken from a design made in the 1950s, but it is based on traditional Finnish lacework which was commonly used for shawls and table linen.

118

Marimekko: Trakatori and Villinarsissi

118 & 119 ■ One of the most influential textile-producing companies, Marimekko from Finland, was founded in the 1960s. The patterns its designers have invented are characterized by their boldly simpli- fied lines and sweeping organic rhythms, as can be seen in these two silk-screen cotton prints by Maija Isola. Both for the textiles and for clothing, Marimekko designs enjoyed widespread international success throughout the 1960s and 1970s.

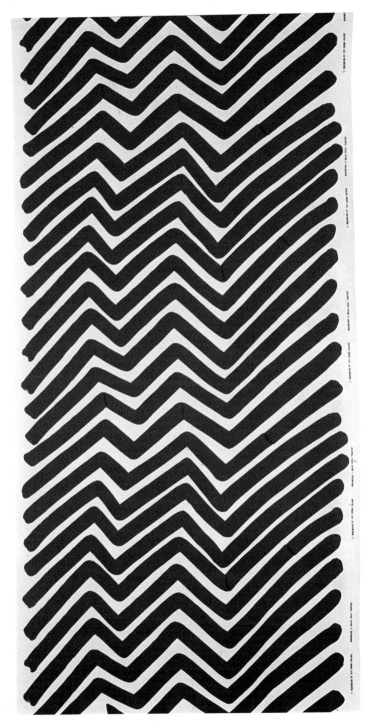

119

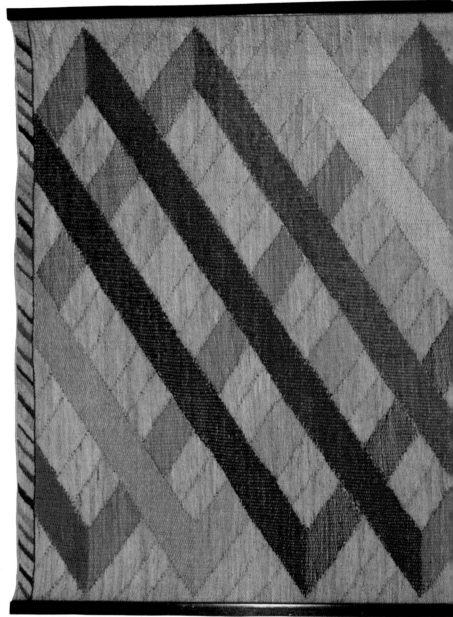

120

Jette Valeur Gemzøe

120 ■ This woven carpet was made and designed by Danish textile artist Jette Valeur Gemzøe. She has taught in Copenhagen and Canada and runs her own workshop in Turkey, a contemporary counterpart to the traditionally strong links between Scandinavian patterns and Eastern decorative arts.

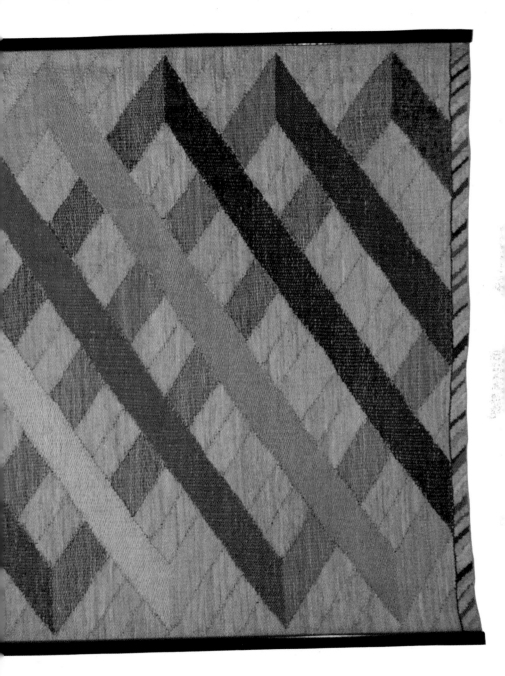

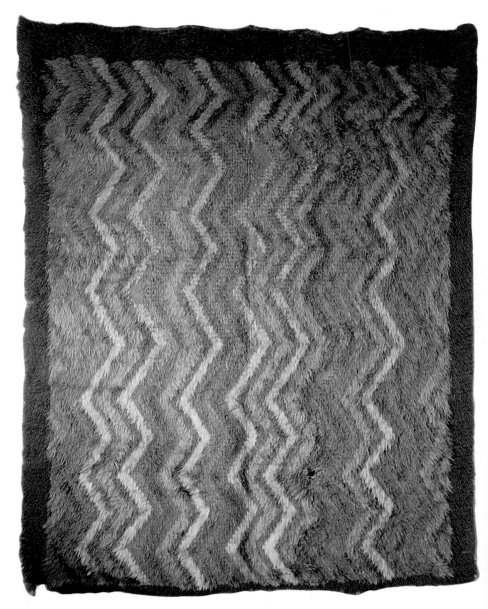

121

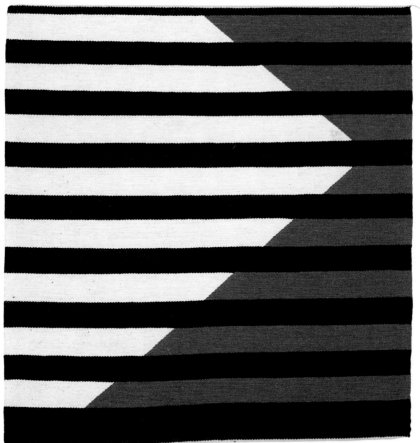

122

Vigg

121 ■ This is a modern rya rug whose pattern is based on one of the most popular and oldest Scandinavian patterns, the Vigg or lightning design [see **98**]. Rya rugs traditionally were often given as presents by prospective husbands to their fiancées.

Hvid vinkel

122 ■ This woven carpet was made by Danish textile artist Jette Kastberg. The title translates as White Angle. Her work, like that of her compatriot Jette Kai [see **123**], aspires to the world of fine arts rather than that of applied or decorative arts.

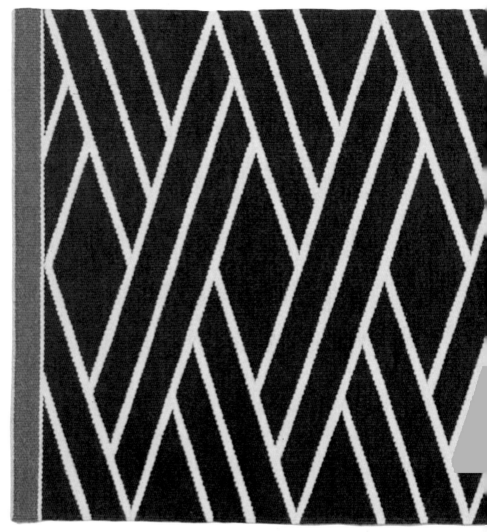

123

Jette Kai

123 ■ The Danish textile artist Jette Kai designed and made this woolen carpet. She has transposed the predilection for the geometric Scandinavian patterns found on embroidered or woven clothing to an article destined as much for the museum as for the home.

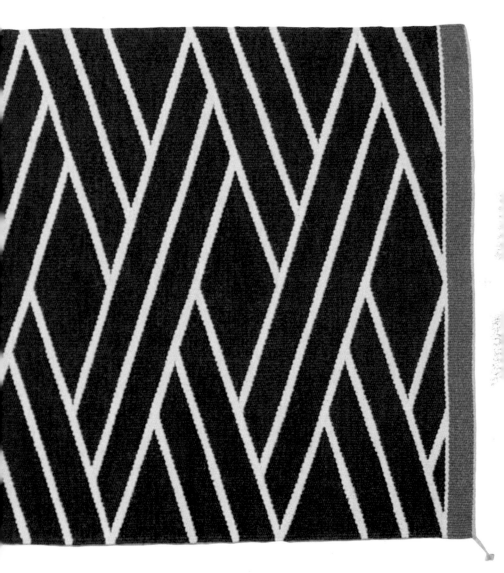

Violet

124 ■ Dora Jung was an influential Finnish fabric designer who turned her attention to traditional woven damasks in the 1950s and 1960s. These had standardly been either pure white or, subsequently, decorated with a narrow and repetitive stock of floral motifs. This detail is from a pattern designed for table linen and reveals how, under the influence of Asian design, Jung was able to revitalize an old tradition. Designs such as this paved the way for further innovations in Finnish fabric design in the 1970s.

124

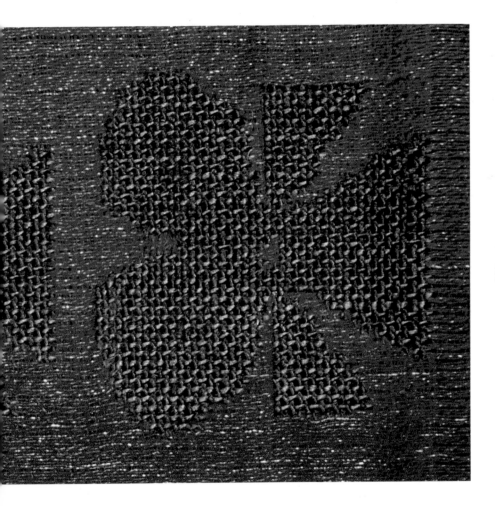

125

Harlekiini

125 ■ The Swedish designer Marjatta Metsovaara based this design for a printed cotton sateen on the traditional diamond pattern of the Harlequin's cos-tume. She has deliberately disrupted the normally regular geometry of the pattern – a modification common to many Scan-dinavian textile designs that were pro-duced in the 1960s and 1970s.

BIBLIOGRAPHY

Anker, Peter, and Andersson, Aron — *The Art of Scandinavia*, 2 vols, London, New York, Sydney, Toronto, 1970.

Beer, Eileene Harrison. — *Scandinavian Design: Objects of a Life Style*, New York, 1975.

Black, D., Willborg, P., and Loveless, C. — *Flatweaves from Fjord and Forest*, London, 1984.

Eldjárn, K. — *Icelandic Art*, London, 1961.

Foote, P.M., and Wilson, D.M. — *The Viking Achievement*, London, 1970.

Geijer, A. — *A History of Textile Art*, London, 1979.

Graae, A., Korneup, A.M., Nevers, J., Ørom, A. — *Tekstilkunst i Danmark 1960–1987*, Copenhagen, 1987.

Graham-Campbell, J., and Kidd, D. — *The Vikings*, London, 1980.

Grimal, P. (ed.) — *Larousse World Mythology*, London, 1965.

Hald, M. — *Ancient Danish Textiles From Bog and Burial*, translated by J. Olsen, Copenhagen, 1980.

Karttunen, L. — *Kirjontamelleja*, Helsinki, 1950. *Kvadratsting Danske*, Copenhagen, 1933.

Krafft, S. — *Pictorial Weavings from the Viking Age: Drawings and Patterns from the Oseberg Finds*, Oslo, 1956.

Mackeprang, M. — *Jydske Granitportaler*, Copenhagen, 1948.

Martin, E., and Sydhoff, B. — *Swedish Textile Art*, translated by W. Barrett, Stockholm, 1979.

Nodermann, M. — *Nordic Folk Art*, Stockholm, 1988.

Olki, M. — *The Handicrafts of Finnish Women*, Helsinki, 1952.

Paine, S. — *Embroidered Textiles: Traditional Patterns from Five Continents*, London, 1990.

Pylkkänen, R. — *The Use and Traditions of Medieval Rugs and Coverlets in Finland*, Helsinki, 1974.

Riiff Finseth, C. — *Scandinavian Folk Patterns for Counted Thread Embroidery*, Seattle, 1987.

Shetelig, H. — *Viking Antiquities in Great Britain and Ireland*, 6 vols, London, 1940–1954.

———— — "The Norse Style of Ornamentation in the Viking Settlements," *Acta Archaeologica*, 19 (1948), 69–113.

Skovgaard, I.W. — *The Technique of Tønder Lace*, London, 1991.

PICTURE ACKNOWLEDGEMENTS

Photo ATA, Stockholm 6. Joseph Anderson *Scotland in Pagan Times: The Iron Age*, Edinburgh, 1883 27. Peter Anker and Aron Andersson *L'Art Scandinave*, Zodiaque, Ste Marie de la Pierre qui Vire, St Léger Vauban, 1969, 16, 17, 18, 19, 20, 21, 42, 43, 44. Archäologisches Landesmuseum der Christian-Albrechts-Universität, Schleswig 15. David Black Oriental Carpets, London 69, 76. Brages Samlingar, Helsinki/photo Bertil Bonns 1932, Svenska Litteratursällskapet i Finland, Folkkultursarkivet 110. The Embroiderers' Guild Collection/photo Julia Hedgecoe 75. P.M. Foote and D.M. Wilson *The Viking Achievement*, Sidgwick and Jackson, London, 1970 12, 13, 14, 30. photo Föreningen Svensk Form, Stockholm 107. Fylkesmuseet for Telemark og Grenland, Skien/photo R.A. Haugen 64. Agnes Geijer *A History of Textile Art*, Pasold Research Fund in Association with Sotheby Parke Bernet, London, 1979 65, 66. Jette Gemzøe 120. J. Graham-Campbell and D. Kidd *The Vikings*, British Museum, London 1980 32. Jämtlands Läns Museum, Östersund 40. Lise Bender Jorgensen *Forhistoriske Textiler i Scandinavien*, Det Kongelige Nordiske Oldskriftselskab, Copenhagen, 1986 11. Jette Kai 123, Laila Karttunen *Kirjontamalleja*, Werner Söderström Osakeyhtiö, Helsinki, 1950 100, 112, 113, 114. Jette Kastberg 122. Sofie Krafft *Pictorial Weavings from the Viking Age: Drawings and Patterns from the Oseberg Finds*, Grøndahl Dreyer, Oslo, 1956 22, 23, 24, 25. Kunstindustrimuseet, Oslo/photo Bridgeman Art Library, London 41. *Kvadratsting Danske Originalmønstre: Samlet og Udgivet af Clara Wæver*, Copenhagen, 1933 104, 105, 106. André Leroi-Gourhan *Documents pour l'Art Comparé de l'Eurasie Septentrionale*, Les Éditions d'Art et d'Histoire, Paris, 1943 3, 4, 46, 47, 48, 78, 79, 80, 81, 82, 83, 84, 85, 86, 87, 88, 89, 90. M. Mackeprang *Jydske Granitportaler*, Høst & Søns Forlag, Copenhagen, 1948 50. Marimekko Oy, Helsinki 118, 119. Marthas Textilarkiv, Åbo/photo Arne Appelgren 1928, Svenska Litteratursällskapet i Finland, Folkkultursarkivet, Helsinki 108. Marthas Textilarkiv, Åbo/photo Hjördis Dahl 1931, Svenska Littertursällskapet i Finland, Folkkultursarkivet, Helsinki 109. Museo Virasto, Helsinki 53, 55, 56, 57, 98, 99. Nationalmuseet, Copenhagen 28, 49, 63, 77. Nationalmuseet, Copenhagen/photo Werner Forman Archive, London 2. Nordiska Museet, Stockholm 10, 61, 70, 73, 91. Nordiska Museets Arkiv, Stockholm 5. Norsk Folkemuseum, Oslo 54, 59, 72, 101. Norsk Folkemuseum, Oslo/photo Bridgeman Art Library, London 74. Mary Olki *The Handicrafts of Finnish Women*, Werner Söderström Osakeyhtiö, Helsinki, 1952 115, 116, 117. Axel Poignant Archive, London 7, 8. Private Collection, Korpo (Houtskär)/photo Maj-Gun Åberg 1974, Svenska Litteratursällskapet i Finland, Folkkultursarkivet, Helsinki 111. Private Collection, Lappträsk/ photo Mirja Vasama 1982, Svenska Litteratursällskapet i Finland, Folkkultursarkivet, Helsinki 121. *Proceedings of the Society of Antiquaries of London*, 2nd series, 23, 1911 34. Rogslöca Church/photo Zodiaque, St Léger Vauban 39. P.T. Schvindt Suomalasia Koristeita: Finnische Ornamente 1, Helsinki, 1895, 93, 94, 95, 96, 97. H. Shetelig (ed) *Viking Antiquities in Great Britain and Ireland*, 6, Oslo, 1954 31. Statens Historiska Museum, Stockholm 52, 58. Statens Historika Museum, Stockholm/photo ATA 36. Statens Historiska Museum, Stockholm/photo Werner Forman Archive, London 9, 37. Statens Historiska Museum, Stockholm/photo Zodiaque, St Léger Vauban 38. Taideteollisuusmuseo, Helsinki 102, 103, 124, 125. Thjødminjasafn Islands, Reykjavik 1, 45, 60, 67, 68, 71, 92. Uno Ullberg, Alarik Tavaststjerna, Jalmari Kekkonen *Kansanomaisia Rakennustapoja ja Koristemuotoja Karjalasta*, Helsinki, 1929 62. Universitetets Oldsaksamling, Oslo 26, 29. Universitetets Oldsaksamling, Oslo/photo Werner Forman Archive, London 33. Uppsala Cathedral/photo ATA 51. Urnes Stave Church/photo Werner Forman Archive, London 35.